color

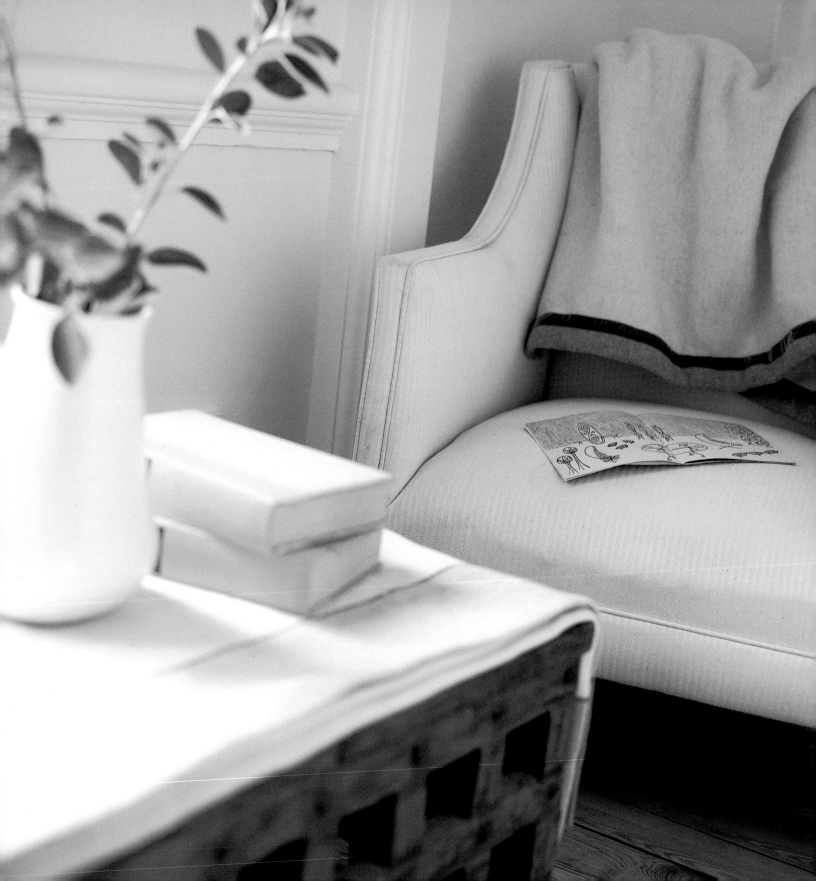

Joanna Copestick & Meryl Lloyd

photography by **Tom Leighton**

color

TIME®
LIFE
BOOKS

Alexandria, Virginia

For Brian and John, Hannah, Julia, and Rosie

Time-Life Books is a division of Time Life Inc.

TIME LIFE INC.
President and CEO: George Artandi

TIME-LIFE BOOKS
President: Stephen R. Frary

TIME-LIFE CUSTOM PUBLISHING

Vice President and Publisher	Terry Newell
Vice President Sales and Marketing	Neil Levin
Project Manager	Jennie Halfant
Director of Acquisitions	Jennifer Pearce
Director of Design	Christopher M. Register
Director of Special Markets	Liz Ziehl

Time-Life is a trademark of Time Warner Inc. U.S.A.

Books produced by Time-Life Custom Publishing are available at a
special bulk discount for promotional and premium use. Custom
adaptations can also be created to meet your specific marketing
goals. Call 1-800-323-5255.

Library of Congress Cataloging-in-Publication Data
Copestick, Joanna.
 Color / Joanna Copestick & Meryl Lloyd : with
photography by Tom Leighton.
 p. cm. -- (Essential style guides)
 ISBN 0-7370-0017-1
 1. Color in interior decoration. I. Lloyd, Meryl, 1958–
II. Title. III. Series.
NK2115.5.C6C88 1998 98-26895
747'.94--dc21 CIP

First published in Great Britain in 1998
by Ryland Peters & Small
Cavendish House
51–55 Mortimer Street
London W1N 7TD

Text © copyright 1998
Joanna Copestick and Meryl Lloyd
Design and photography © copyright 1998 Ryland Peters & Small
Printed and bound in China by Toppan Printing Co.

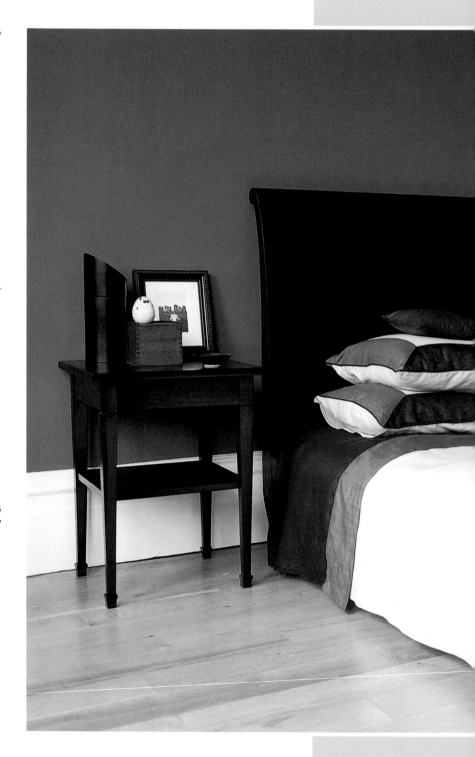

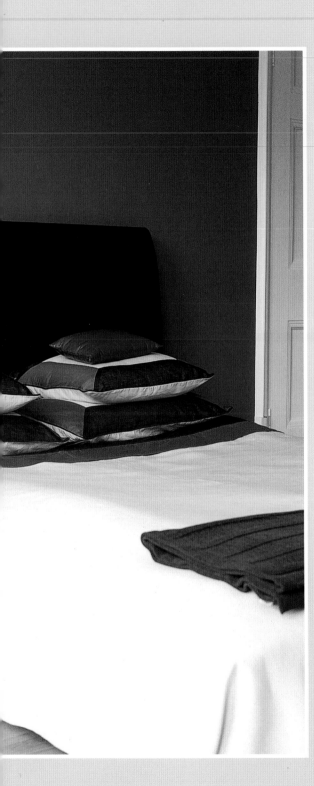

contents

introduction: why color?

"Color is a basic human need...like fire and water, a raw material, indispensable to life." *Fernand Léger,* PAINTER

Color is a universal language. It stimulates the emotions, shapes cultures, and forms the background of our world. Talking about color evokes music, nature, and personality traits, and unlike other decorative devices, it has a human dimension that is irresistible. Quite simply, color can influence mood, create atmosphere, and lift the spirits, allowing creativity a safe and sunny outlet.

Color has never been more accessible. Whereas once we were limited by cost and the availability of pigments and dyes, now color is everywhere: in vivid tones, gaudy highlights, and on an array of surfaces. Color has gone overboard, and this book is a response to the bright color overload of recent years, examining the nature of color and asking for a return to subtle ground. It explains how colors work together and suggests ways of combining warm soft neutrals, rich deep shades, and cool strong tones to bring warmth, energy, and simple pleasure to a home. *Color* is a visual celebration of colors that don't date; colors that capture a contemporary mood but that can be used in any setting; and tones that will soothe the spirits, yet will suit the way we live today.

Seeing color, using it, and surrounding yourself with a personal palette that works for you produces a calming backdrop for daily life. Color is one of life's luxuries. A home suffused with colors that feel right is always a comforting place; rooms become all-embracing and alive with interesting combinations of tone, texture, and scale.

But you don't have to soak the walls in lurid planes of saturated shades to achieve a sense of color. Small details will punctuate the space with a sure touch. Curtains, pillows, throws, and lamps can be as valid as a whole wall of deep turquoise or emerald green.

To help you with the process of color selection, the book guides you through a few basic lessons in color theory. It then goes on to explore the fundamentals of color and light, texture, materials, and proportion before dividing into five core color groups—Linen, Paper, and String; Chocolate, Amber, and Silver; Ice Cream, Sherbet, and Biscotti; Sea, Sky, and Driftwood; and Red Wine and Roses—containing over 25 irresistible color schemes.

Each color group in this book started as a collage of favorite images and materials, so begin to keep a visual color diary or dictionary of your own as a source of inspiration. Every time you find a piece of fabric you love, keep a beautiful leaf or flower, or spot a favorite paint sample or magazine image, put it in a book. Divide the book into sections such as color groups, rooms, subjects, places, fabrics, or seasons and add to each section over time. It's interesting to build up a picture of what you respond to intuitively and to discover other influences such as advertising and fashion. We have concerned ourselves with pure, plain color rather than pattern, but gathering together images that inspire you is the best way of sparking off ideas. Start your own color dictionary, decide what colors you love and why you love them, then see what happens.

pure color

"Color belongs to our being; maybe each
one of us has his own." *Le Corbusier*

color explained

Defining colors and decorating with them is a rewarding experience once you realize what can be achieved using simple shades. Explaining our responses to color is as much about an emotional reaction as it is an exact science. Discovering what it can do to a room, possessions, or clothes goes a long way to working out what makes you feel good.

the power of color

Consider what it is about your favorite object that moves you. Is it the quality of light on a certain texture; one color against another opposing color; or a combination of tones in one color that makes a perfect picture? Looking, then looking again, is the only way to get a feel for color and how it works. You may be surprised that a classic combination does nothing for you, while a deep indigo fabric with a chocolate brown accessory may hit the spot. Color is so personal that one person's purple is another's deep blue.

Color has always had symbolic significance as well, affecting perception and mood in a striking way. The psychology of color and why people prefer certain shades is constantly under investigation. Color gurus like Johannes Itten, the Bauhaus teacher, and Faber Birren, an academic and color consultant, enlarged the ideas first explored by Isaac Newton. Faber Birren undertook much research from the 1930s onward, placing his own interpretation on the color wheel and influencing the way that human responses to color were measured. His work led to a much deeper appreciation of the effects of color on our daily lives. Elements of his research, which included color preference tests, led advertisers to the realization that certain colors sell products better than others. Clearly, color is always there, however subliminally, affecting the way we see things.

the color wheel

Whenever color is analyzed, an explanation of the color wheel follows close behind. It was Isaac Newton who discovered that white light splits into the colors of the spectrum when shone through a prism. Each part of the spectrum—red, orange, yellow, green, blue, indigo, and violet—has its own wavelength. We see colors when different wavelengths are reflected off the surface of an object. For example, a chair looks blue because it absorbs all the wavelengths of light except for blue. Newton devised a color wheel to explain his findings, and this device formed the basis of many variations created by the theorists who followed him. Johannes Itten produced the color wheel that is most recognizable today. While teaching at the Bauhaus, he used blocks of primary, secondary, and tertiary colors to form a wheel and visually represent their circular relationship. Although it is a convenient way of discussing color, the wheel can stifle a more spontaneous approach to color-combining. Bear in mind the theory, but don't be too constrained by the implied rules.

The color wheel works by linking the primary colors of red, blue, and yellow with the secondary colors of violet, orange, and green, and with the tertiary colors. These are created by mixing a primary with its adjacent secondary color. For instance, lime green can be made by mixing green and yellow. In the traditional color wheel, there are six tertiary colors—red-purple, red-orange, orange-yellow, yellow-green, blue-green, and purple-blue. Most of the colors visible to the

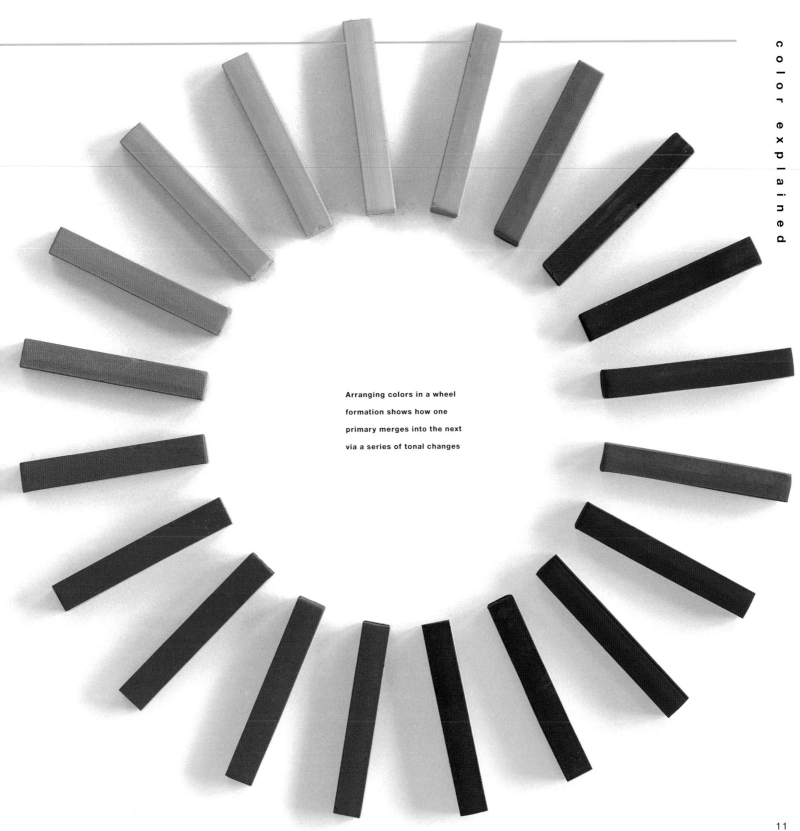

Arranging colors in a wheel
formation shows how one
primary merges into the next
via a series of tonal changes

Left **Complementary colors are those that are directly opposite one another on the color wheel, and combinations of complementary colors are always striking, emphasizing the richness of both colors. Here, the vivid tones of fresh oranges are made even stronger when placed against blue tissue paper. The textures of the oranges and the paper also play a part in the effect.**

human eye can be mixed using the three basic primary colors of red, blue, and yellow in different hues and values, but it is not possible to create these colors by mixing together any of the other colors. The human eye is an amazing organ. Under good light, it is capable of discerning up to ten million different colors.

Complementary colors are those that are diametrically opposite on the wheel, such as red and green, blue and orange, and scarlet and lime green. They are the strongest juxtaposition of coloring you can achieve because they contrast most powerfully, emphasizing the strongest tones of each another. They can be gloriously uplifting or create a clash, depending on whether you enjoy timid or vivid tones.

Just as important as the color relationships within the color wheel is how colors themselves vary. Every color has different hues and tones that give it a particular color bias. Certain colors, such as blue, can look more green or purple depending on their depth of hue, whereas orange at one end of its spectrum will actually turn brown. This is why colors that should work together sometimes appear uncomfortable with one another.

Harmonious colors are those that are placed next to one another on the wheel between two primaries. They often work well together since their natural color bias is toward the secondary color of that part of the color wheel. Harmonious colors that span and include a primary color such as yellow-orange or yellow and lime green need to be treated with caution since they can be too powerful for the eye when mixed together. When choosing paint, select paint samples

a couple of shades lighter than your perceived finished color. The paint will invariably look darker over a large area of wall. Always try to experiment with a patch of color before buying your paint.

mixing colors

You can achieve countless gradations of tone by mixing together differing quantities of the twelve main colors. Mixing two complementary colors together will give a dull gray color, yet placed side by side they will intensify the other's color. The degree to which two complementaries become gray when mixed together is known as color saturation or intensity. In its purest state of maximum saturation, red will be a rich, vibrant scarlet. At the other end of the scale, it becomes much more neutral, as it approaches the dull gray color at the center of the wheel, its lowest saturation.

Color value is often linked to the brightness of a color. It relates to the amount of lightness or darkness in a color and can be altered by the addition of black and white. When two color pigments of an equal intensity, or value, are mixed, the resulting color is darker, since more wavelengths are absorbed when the values are combined. The process is called subtractive addition, because the light reflected off the surface is subtracted, or reduced, from the color pigments.

Additive mixing is achieved by combining two shades of primary colors in order to make a third. For instance, blue and yellow make green, but the green can be pushed from a vivid lime green to deep apple, depending on the hue and saturation of the original colors.

Left **Lush pink tulips on top of apple green stems shout vitality and richness. Placing a vase of flowers in a room is an easy way of bringing a splash of vibrant color to an otherwise subdued color scheme.**
Right **Delicately veined pansies show just how versatile nature is at creating its own vital color stories that owe nothing to artificiality.**

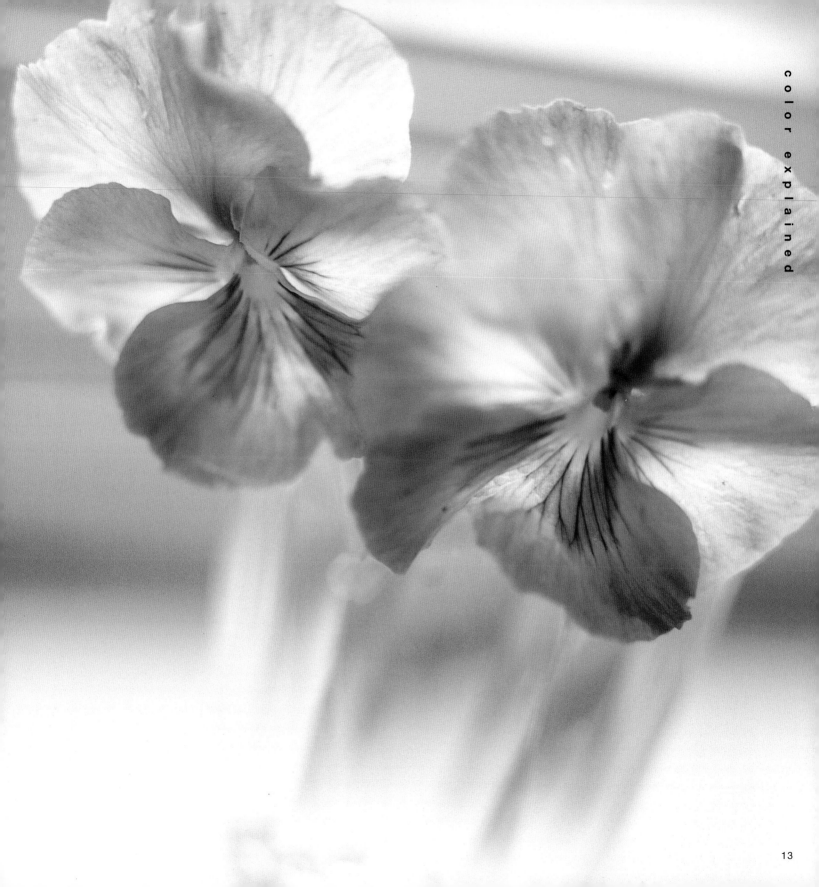

black
and white

D ebates rage over whether black and white are true colors. An object will look black when all the wavelengths of the spectrum are absorbed in its surface and white when all the wavelengths are reflected off the surface. Black and white placed side by side are a classic and complementary partnership, slick, clean, and graphic. They are a combination that is at once understated and bold. Just think of black type on white paper, white stars in a night sky, zebra stripes, and black and white clothes. The sliding scale between black and white produces shades such as bone, biscuit, gray, and steel. Gray is the one absolutely neutral color. It throws all the other shades into complete balance, neither emphasizing nor enveloping surrounding colors. Gray can also be achieved by mixing together two complementary colors of equal hue. Paint a floor gray and you have a neutral base for decorating. It neither screams out nor detracts from what else you do in the room. Gray also eases the transition from one strong color to another when placed between them.

Black and white give tonality to specific hues. If you add black to red, the result will be deep brown, whereas white converts red to ever softer shades, graduating from poppy red at one extreme to soft pastel rose pink at the other. When using light hues of a specific color, make sure that the base pigment is quite a strong tone; otherwise, you will end up with a mainly white color and a hint of pigment, which will look like an insipid pastel.

ch

White can be used to correct a strong color that is too deep. As you will know from experience, choosing wall colors from paint charts is notoriously difficult, particularly when there are such a confusing number of different shades presented on one large card. If you find a color too domineering once you have tried it on the wall, add white until you achieve a lighter, less aggressive shade. White can also be used to dampen down the impact of strong colors that are already there. Used on doors, dado panels, floorboards, fireplaces, and woodwork, white will break up and define a room.

Black also works well as a bold definer in a decorative scheme. When it is used on picture frames and along moldings, on pillow piping, and baseboards, black creates an effect that is both graphic and elegant. Much used in the Empire-style rooms of the 18th century, with white as its foil, black is best used in small doses on accessories, furniture, and some architectural detailing.

Black and white are useful tools for appreciating the importance of hue in color. When looking at how one color, such as blue, graduates from a deep indigo to a pale sky, it helps to imagine a color chart in black and white to see the difference in color saturation from one end of the spectrum to the other. Color is just as much about intensity as it is about shade.

alk, steel, charcoal

Left **A pile of pillows covered in sensual fabrics, such as leather, suede, and rich velvet, hint at the rich variety of tones that exist within the monochrome spectrum. In between brilliant white and midnight black lie a host of subtle shades such as steel gray, bone, and ash.**

natural selection

Textures and colors that occur in nature are often more wondrous than any machine-made fabric or mass-produced material. Think of the multishaded scales on a mackerel or trout, the gradations of tone and texture within an oyster shell, or the translucent lime green of a cherry tree leaf. Basing a scheme around the neutral palette always produces a calm, unambiguous atmosphere that can be enriched with varying textures and shades of gray, black, or white. But nature also produces an abundance of strong colors that combine to give the impression of only one overall color. A fig, for instance, can appear to be a uniform, muddy, deep purple, but look closely and you will find a rich conglomeration of lime green, bright violet, and rich charcoal.

Natural objects are very often the starting point for an entire color scheme. A collection of pebbles or shells found on the beach and transferred to a glass tank or wooden bowl can define the whole approach to a room. Or perhaps the abundance of shades of green

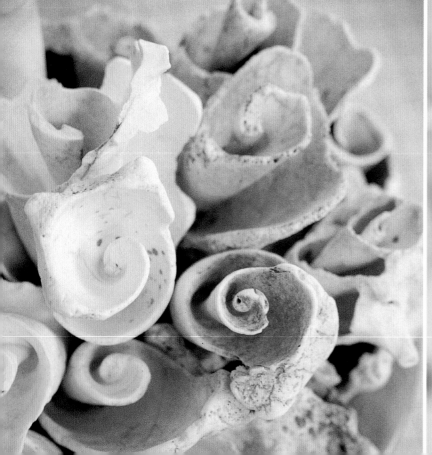

found on the leaves of an artichoke will set off an idea for a space in which the tonal relationships of one color are explored. Coming at color from one small piece of the natural world, a scrap of fabric, or a fragment of china can be the most successful way of making sure your personal responses to shade and tone are included in an overall plan. This is where your personalized dictionary of favorite images will prove invaluable. By having a visual record of those elements of the natural world that have inspired and moved you, choosing a color scheme becomes much easier.

Sometimes un-nameable colors combine to provide a complete sensation. Bread, sugar crumbs, and sea salt can all be deeply rich in tonal variation, providing shades and nuances that would take days to evoke using watercolors or oil paints. Imitating color stories that are inherent in nature is a way of creating schemes that are innately cohesive and credible.

The texture of such objects is another source of decorative inspiration. Matte smooth stones or the elegant contours of a glass bead contrasted with the pitted surface of a walnut or the knotted edge of weathered driftwood provide visual comparisons that make their own drama. Rough and smooth, regular and random tableaux are vital elements in schemes where color works on a variety of planes and surfaces. In such cases, man-made patterns on fabrics or walls would only be an intrusion into the natural flow of surfaces.

From left to right **Tropical seashells have gnarled and furled edges in shades of white and gray that fold in on themselves like stiff parchment; the delicate petals of this pompom-like viburnum flowerhead, which is composed of numerous small flowers,** are beautifully and faintly tinged with soft lime; sugar cubes have a rocky texture that throws light back and forth; this anemone has its own natural color harmony, with its delicate color combination of sherbet pink with black detailing.

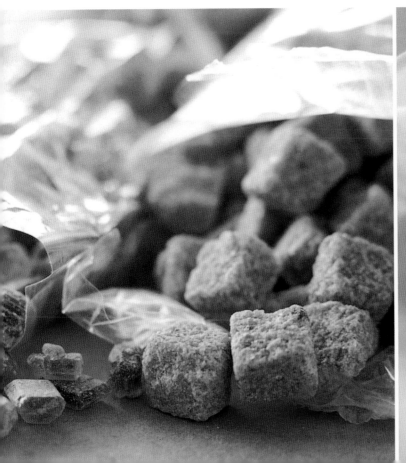

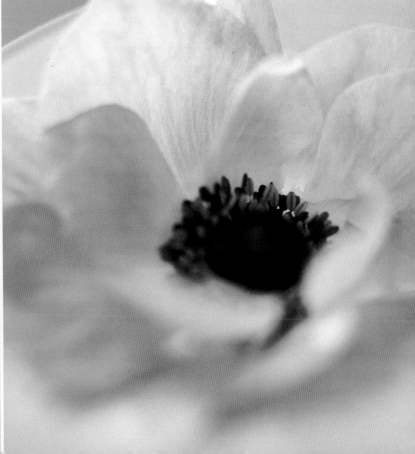

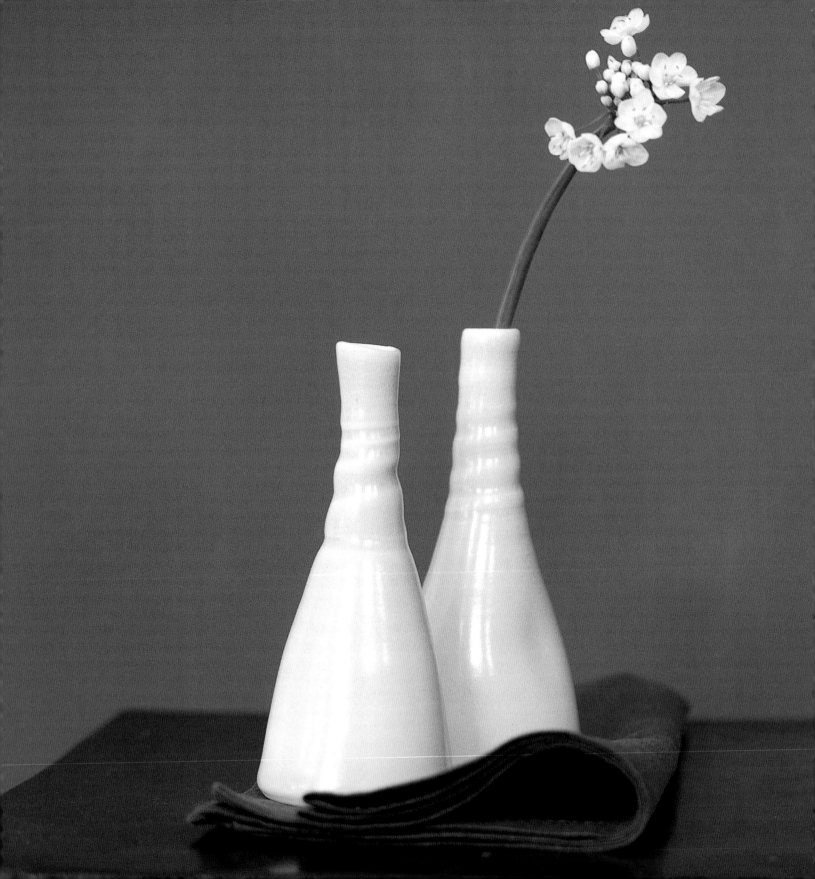

language of color

color and texture

Texture is the secret ingredient that makes colors come alive. In fact, some colors only find their true potential in a happy marriage of hue and material. White linen and black leather, for example, are common associations.

We perceive texture in two ways. We can see effects as light is reflected back from different textures, whether shiny, matte, opaque, translucent, smooth, or rough, to name a few, but we can also enjoy texture physically, when something feels as beautiful as it looks.

Plain ivory drapes are much more satisfying when they have a secret texture. Only by touching do you realize they are made from a heavy washed silk that gives the ivory luminosity and depth. So, the simpler your choices, the more important a role texture can play. Elaborate patterns and complex styling have their own agenda; plain colors and unfussy styles give greater scope to the power of texture.

Creating the right balance between hard and soft textures is the key to generating the right mood for a certain room. An all-white bedroom may need the warming effect of a honey-colored floor, but the color can come from glossy wooden floorboards, sisal matting, sleek wool carpet, the buff sheen of linoleum, cork, or stone. It is getting the mix of textures and colors right that works the magic.

All pictures **Looking at objects rich in texture and tone will help you gauge your preferences when choosing colors. You may return to an old basket or a favorite pair of suede shoes. Often it's an object's texture that lends depth to a color, pushing you in one direction or another.**

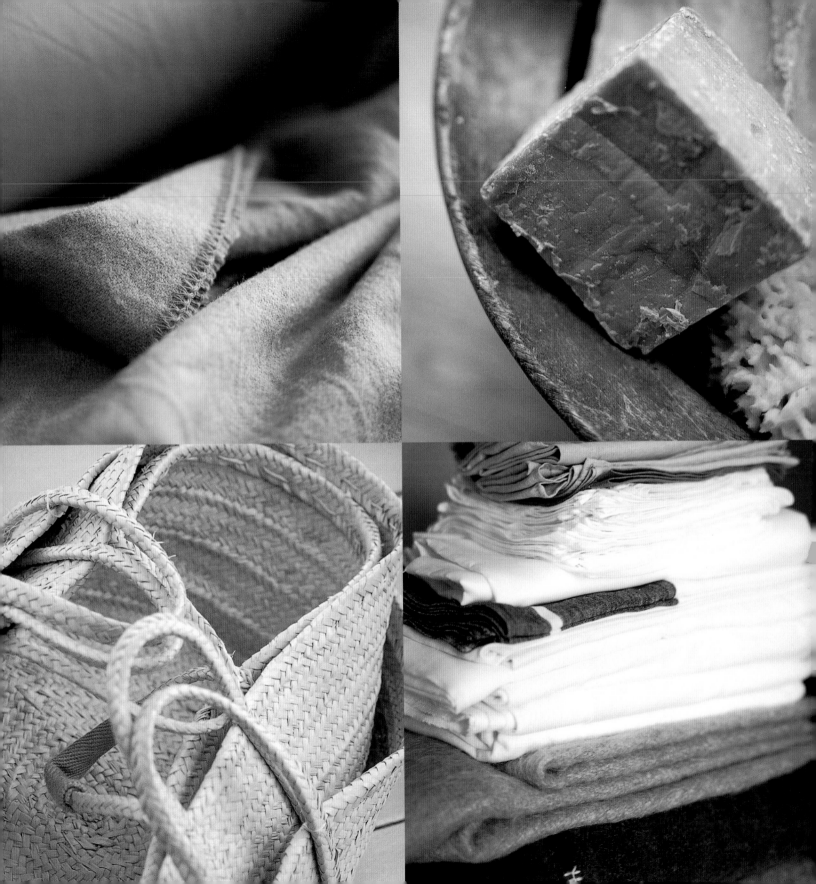

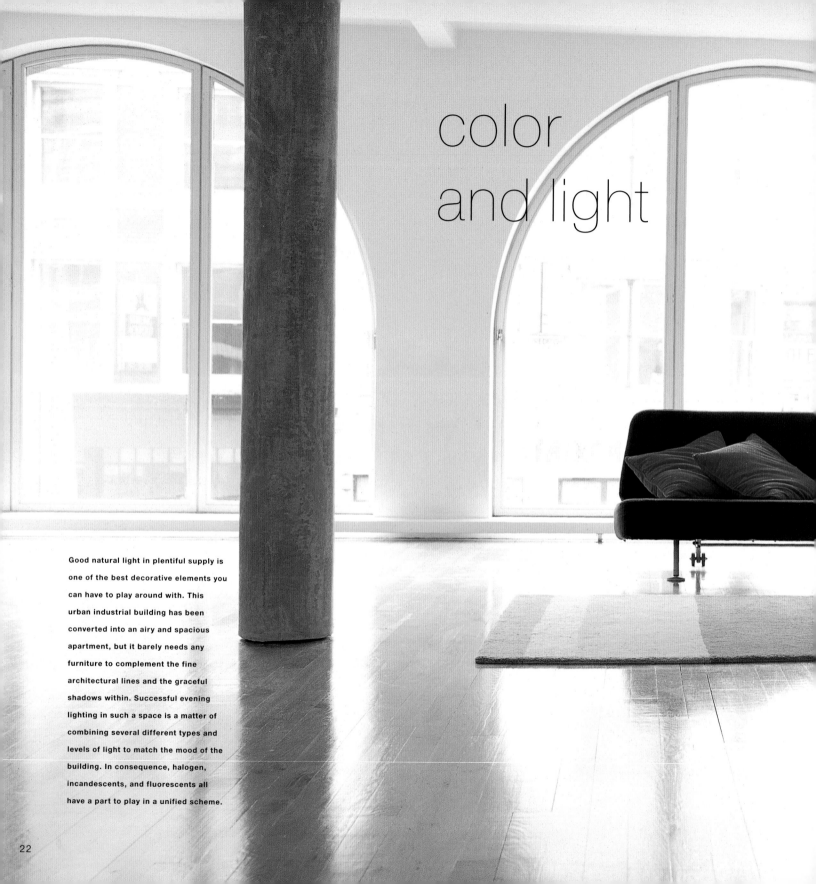

color
and light

Good natural light in plentiful supply is one of the best decorative elements you can have to play around with. This urban industrial building has been converted into an airy and spacious apartment, but it barely needs any furniture to complement the fine architectural lines and the graceful shadows within. Successful evening lighting in such a space is a matter of combining several different types and levels of light to match the mood of the building. In consequence, halogen, incandescents, and fluorescents all have a part to play in a unified scheme.

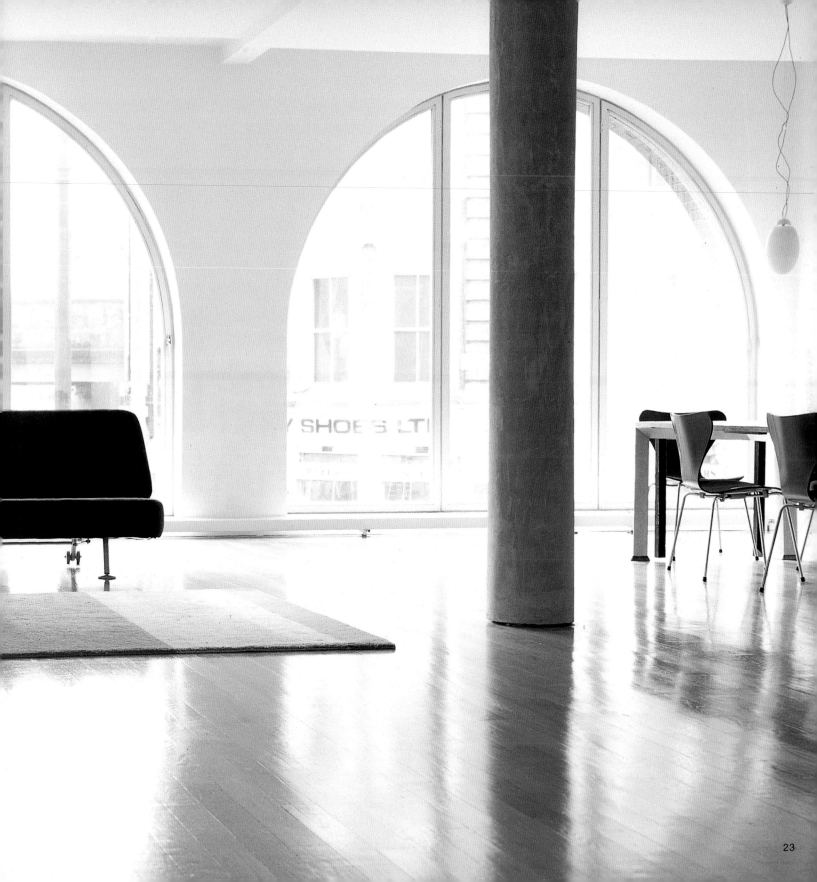

The power of light, in all its forms, to transform the quality of any particular color and space is an impressive decorating tool. Always underestimated, light has the capacity to kill or cure a color. When choosing colors and fabrics, assemble and study them in natural daylight, at different times of the day, and again under the artificial light sources you will use in a room before you decide on the exact shade to use. Some colors, such as light lilac or terracotta, seem to change shades completely with the slightest variation in natural or artificial light.

Bright natural daylight is the truest light with which to work, closely followed by halogen, which most accurately imitates the properties of natural light. Incandescent bulbs have a yellow-orange tinge that affects the coloration of rooms and objects, while fluorescent tubes give off a harsh, bluish tinge. Even natural light varies through the day. Just after dawn, the light will be pinkish; at midday the light will be more yellow, while dusk brings a reddish glow. Seasonal variations and geography also strongly affect natural light.

A white ceiling will reflect 10-15 percent more light than a color tint, so it is important to consider ceilings and floors when adding color to a room. The decorating norm is to allow the flooring a neutral tint so the eye is not drawn to it. Similarly, a pale ceiling will increase the sense of height and space in a room and allow the eye to concentrate on the walls, the color, and the other decorative elements.

Seasonal differences play a part, too. Just as landscapes look dramatically different beneath a summer sun and an autumn sky, so rooms will vary, too. However, the eye has a built-in comparative quality. Even if a dish of red apples looks slightly bluer under one light, the eye will compensate by subtly re-casting the other colors around it so they harmonize into a new, slightly altered spectrum.

Think about how and when you will use a room before choosing a color. A living room with good natural light will be able to take a deep shade more easily than a north-facing room, where any natural light should be enhanced as much as possible by choosing pale tones of cream or yellow. In a room with few windows, where the light

Above **When planning a color scheme, try different color swatches on a wall and view them under a variety of light sources. Some colors, such as lilac and red, are transformed by sunlight and incandescent or halogen light.**
Right **Flat color swatches never reveal their true tonal variations. They show** colors but not how they will perform in a room. So, paint small boxes in the colors you want on the walls. They will echo the sense of enclosure in a room and give a truer picture of how planes of light will work. Colors always vary in intensity according to what proportion and where they are applied.

is mainly artificial, choose a color that always looks good under the particular light source. Incandescent bulbs tend to make pale yellows recede into nothing at night, while terracottas can seem orange, mid-greens assume more of a yellow-green tone, and purples look positively brown and muddy. Yellows, greens, and creams will lighten and brighten gloomy spaces. A strong red under incandescent light will appear slightly orange, while under fluorescent strip lighting red seems more magenta. Under street lighting, which is yellow, it becomes brownish.

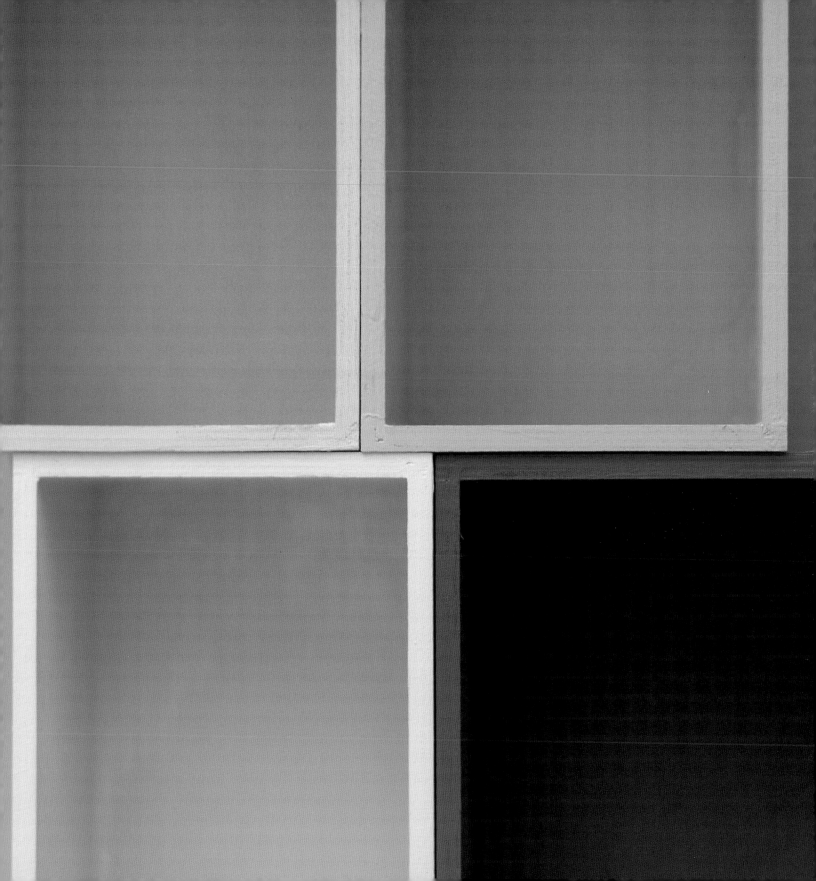

color and proportion

Choosing particular colors as a means of enhancing the shape and size of a room often comes as a decorative revelation when people start to experiment with color. While there are certain given rules regarding the properties of certain colors, these are often broken by professional decorators who push the boundaries of color theory to their limit and come up with solutions that work in spite of themselves. Before decorating a room, think about its proportions and architecture, decide which elements you want to emphasize or disguise, then base your color choice around its virtues, whether they are a high ceiling, plenty of natural light, unusual architectural features, large pieces of boldly colored furniture, a glorious floor, or a large space. Color can also be used to manipulate awkward rooms into feeling more comfortable. For example, you can use color to disguise the confines of small rooms, narrow spaces, low ceilings, and dark spaces.

A dark color such as deep red used on walls, for instance, will enclose a space, making a room seem smaller but also more cozy and welcoming, because the color advances in on the space. Even in a room that is starved of bright natural light, dark red can bring a sense of comfort and security. Other advancing colors to use are orange, brown, and bright yellow. When used only on a ceiling, an advancing color will have the effect of making a tall room appear wider and the ceiling lower, especially if the floor also has a dark covering. Any dark color can be used to visually reduce the dimensions of a room, in the same way that wearing black is always flattering to the figure. Another important decorating guideline to remember is that plain colors will always be more space-enhancing than patterns.

Colors that appear to recede—which makes them the best choice when you want to create a feeling of space—are blue, green, white, and pale shades in general. Although blue is usually labeled as a cold color that should be used with care, dark blue walls can be as enveloping and inviting as deep red, as long as you choose a suitable

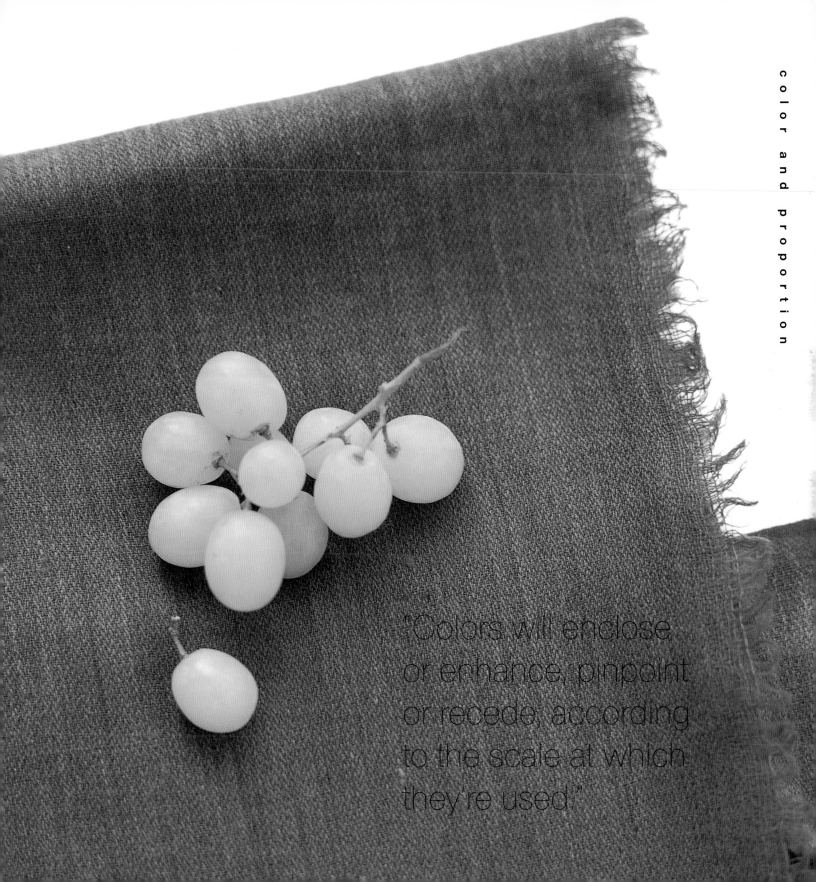

"Colors will enclose
or enhance, pinpoint
or recede, according
to the scale at which
they're used."

Right **The eye plays subtle tricks on the mind when you view certain colors together. A classic test of this phenomenon is to watch how the same red square varies in perceived size and intensity depending on the color that surrounds it. Against a sea of white the red square looks crimson, but as the shades around it gradually develop from gray to black, the square deepens in intensity until it becomes a vibrant scarlet. This optical illusion can be used in decoration to achieve certain effects. So, if you want to draw the viewer's attention to an object or subdue its impact, then you should match the color of the background accordingly.**

Far right **This decorative scheme uses pale and dark colors very effectively. The eye is drawn to the dark chair against a pale back ground and to the pale picture against a dark background.**

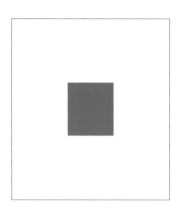
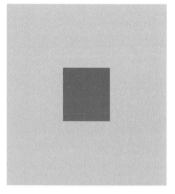
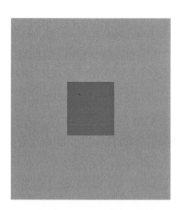
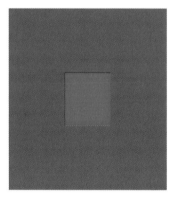
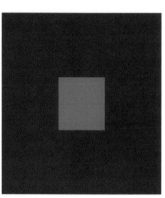
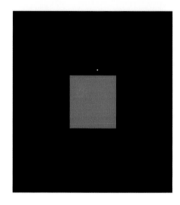

shade in a fairly well-lit room. Pale tones used on the walls of a narrow room will make it appear wider. When used on the floor, they can bring a sense of air and light to a room, and on a ceiling they appear to lift the lid, creating more space above. In traditional decorating terms, floors and ceilings should be kept either neutral or dark, thus throwing the visual emphasis onto walls and furnishings.

Deep colors should be used on the ceiling with care—a white room with a white-painted floor and a ceiling painted deep midnight blue, extending down to a molding, will feel open but slightly dim, as if a night sky is always lurking above it. The tonal value of colors is important when you visually adjust the proportions of a room. While blue and green are thought of as cold colors that freeze a room's atmosphere, vivid turquoise blue can be almost as warming as soft terracotta. A pale tone, however, would definitely create a less appealing aura. Using monochromes to break up expanses of color

can rest the eye and help define a room. Color used above or below dado height, punctuated with a monochrome ceiling molding, is often more successful than a room filled with one color.

As well as visually altering the size of a room, color can also be used over small areas as a highlight to punctuate a space. A bunch of white ranunculus against a lilac wall or vivid red tulips against a white wall employ the same principle with radically different effects. Dropping in accents of color using cushions, curtains or blinds, flowers, and pictures can steer a color theme in a certain direction or inject splashes of contrasting color. In a large room that has alcoves or in an open-plan space where one sphere of activity leads into another, color can be a great definer, marking the transition from one space to the next. On a smaller scale, objects of a certain color arranged on a mantlepiece or displayed on shelves or tables can enhance the proportions of a room or add definite colors.

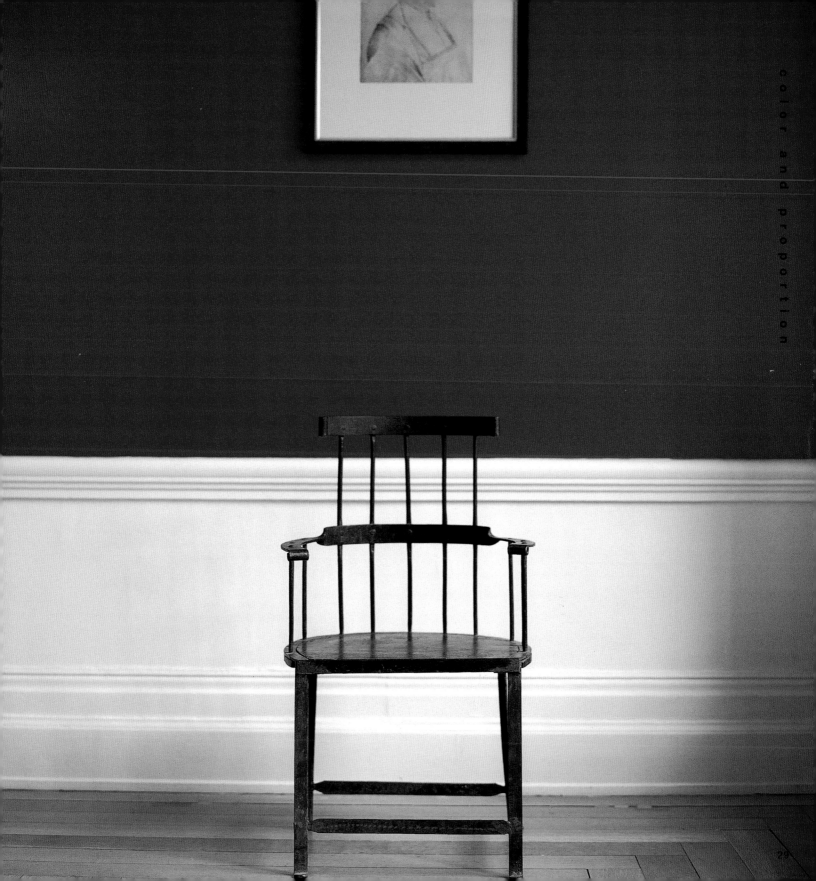

"Consider the quality of light, texture, material, scale, and proportion. They have real significance."

decorating with color

"Colors that are barely there create a
calm backdrop for our daily lives."

linen, paper,
&string

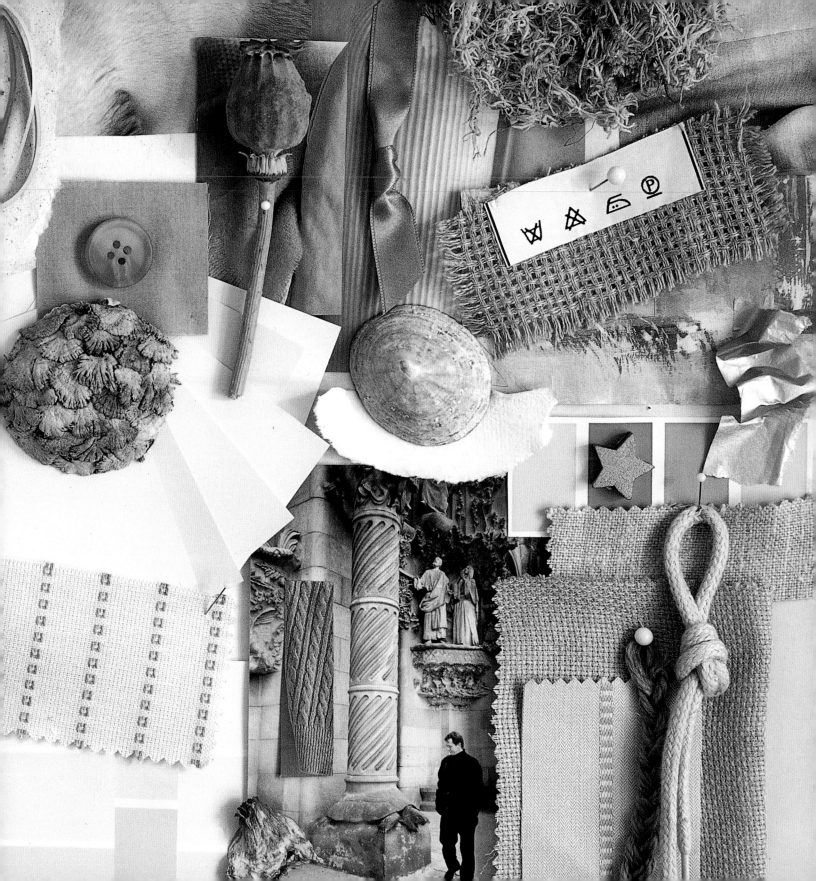

The fascination for color schemes of white on white or of "no color" is enduring and understandable. Pure, simple, and unfailingly calm, a palette of neutral whites can seem like the safest combination in the spectrum to compile as well as one of the most subtle. Balancing white with other materials and textures is the essence of decorating with cool neutrals. To achieve harmony rather than bland uniformity, it is important to get the right textures and tones within a color scheme based around the natural palette. Filling a room with a variety of textures, on fabrics,

the invention of titanium oxide in 1919 lead to the introduction of brilliant white paint. The modern movement quickly latched onto this purest of all colors. Architects such as Le Corbusier and Charles Rennie Mackintosh and decorators like Syrie Maugham each used white as a trademark of their interiors. Brilliant white can be successfully opalescent or uncompromisingly cool. It cools warm climates and brightens cold ones, but it should be used with care in northern climates, where a slightly off-white can be more flattering. Brilliant white will appear too harsh and unflattering when natural

"Simple things such as fresh milk, new-fallen snow and white lilies"

walls, and floor, will set up an intriguing series of surfaces to attract the eye and provide a respite from the similarity of the colors. Use white as an easel for bringing tone and texture to a room and then embellish it with darker accessories and furnishings.

True white paint is a rarity. There is inevitably a subtle color bias depending on the available light, because white is, in fact, a combination of all the colors of the spectrum with no light absorbed in it. This means that the white will assume tints of blue, pink, red, green, or gray, depending on the surroundings and the properties of the paint. Although not as pure and simple as it first appears, white is always there, soaking up other colors until it achieves a purity that is quite its own.

Finding the right white paint to use is often a long quest through the subtle tones, since white comes in myriad shades these days. Where once only a dirty white was possible using natural pigments,

"Linen for luxury, paper for simplicity, string for texture"

light is not flooding in from all directions, chilling the atmosphere so much that the air seems palpably cooler.

However, white is an undeniable luxury. It creates a sense of peace in any room, allowing a clear backdrop for the addition of layers of color and texture. Once furniture, paintings, touches of wall color, and fabric are added, white can create a color scheme that is completely there, yet tantalizingly elusive.

White has always been associated with purity and peace, simplicity and romance. It is symbolized by simple things such as

"White is always there, soaking up all the other colors until it reaches a purity that is quite its own."

wedding dresses, snow, and delicate lilies. Think of clean muslin drapes; delicate lace and naïve, embroidered linen; cotton damask on chairs and bed linen; chalky white walls and biscuit-colored tongue-and-groove. Think of the quality of crisp, white linen, the translucency of voile, the purity of white woodwork, and the warmth

"Think of the quality of crisp, white linen."

of lambs' wool, all clear white tones to soothe and heal. Such is their calming effect that the cool neutrals are many a decorator's choice for providing a clean, welcoming space at the end of a long day wading through an abundance of different colors, patterns, and textures. These colors are ideal for clearing the mind and calming the spirit like no other color palette.

When should you use white? One of the most common reasons for using white is to create a sense of space as well as to enlarge and brighten small rooms. White looks good in rooms where the ceilings and walls are irregularly shaped, pulling the emphasis away from the unusual architecture and enhancing light levels. It is an easy companion for rich surfaces such as traditional gilt and gleaming chrome and is excellent for taming and subduing strong colors.

Although white is uncompromising when it comes to showing dirty marks and needs careful treatment if you are to keep it looking pristine, the effort is worthwhile. It goes fantastically well with the mellow tones of wood, from deep cherrywood to light pine, from the cheap but chic texture of plywood to the seriousness of mahogany. It is also the perfect foil for natural textures and materials, as equally at home with driftwood as with vibrant flowers and frosted glass.

Where should you use white? It works very well in kitchens and bathrooms where a sense of clean order often prevails. It always creates a feeling of space and light, the two components that are synonymous with a contemporary approach to decorating, with its emphasis on the room rather than the contents. White can verge on the cool in northern climates where generous natural light is in short supply, but off-whites will always brighten and enlarge the dullest of such rooms. It can be used in combination with strong color to play visual tricks on the eye. For example, you can make a long narrow room seem far wider by painting the walls at each end with a strong color and the long side walls in white. This painting technique will draw the end walls in and make you feel you are in a wider room.

Creating a neutral palette usually involves employing a variety of white-related shades and tones to complete the picture. Subtle grays, hints of wood, and a variety of surfaces, including linen for tables and beds, heavy-duty muslin for upholstery, a touch of chrome on door handles or surfaces, and natural matting for flooring are all elements that complement white walls and furnishings.

Introducing accent with other colors and materials into all-neutral schemes can be done in a number of ways. Flowers are an obvious choice, lending naturally brilliant shades as graphic counterpoint. A rug of several related shades will give a sense of enclosure and link a series of disparate objects into the scheme. Wood in various tones on windows, doors, floors, and furniture is often all that is needed to bring neutrals to life. Additional texture may be in the form of throw cushions, knobby throws, dramatically shaped ceramics, or a collection of glass objects. Porcelain, pure and translucent, is also a great asset in a white room. The way that light skips through planes of glass, whether they are in the form of vases, colored vials, or frosted panels, is endlessly fascinating to watch. Different times of the day give wildly different qualities of light (artificial sources lend further variety) and placing the objects against a colored wall or near to a source of other strong tones will also shift the emphasis.

Work with a white palette to create an amalgamation of different neutral surfaces, textures, and materials. The result will be a natural scheme that becomes an effortlessly relaxing space. The schemes on the following pages all take their cue from the white spectrum, developing it to create uncluttered cool rooms.

"Achieve harmony rather than bland uniformity."

"Balancing white with other materials and textures is the essence of decorating with cool neutrals."

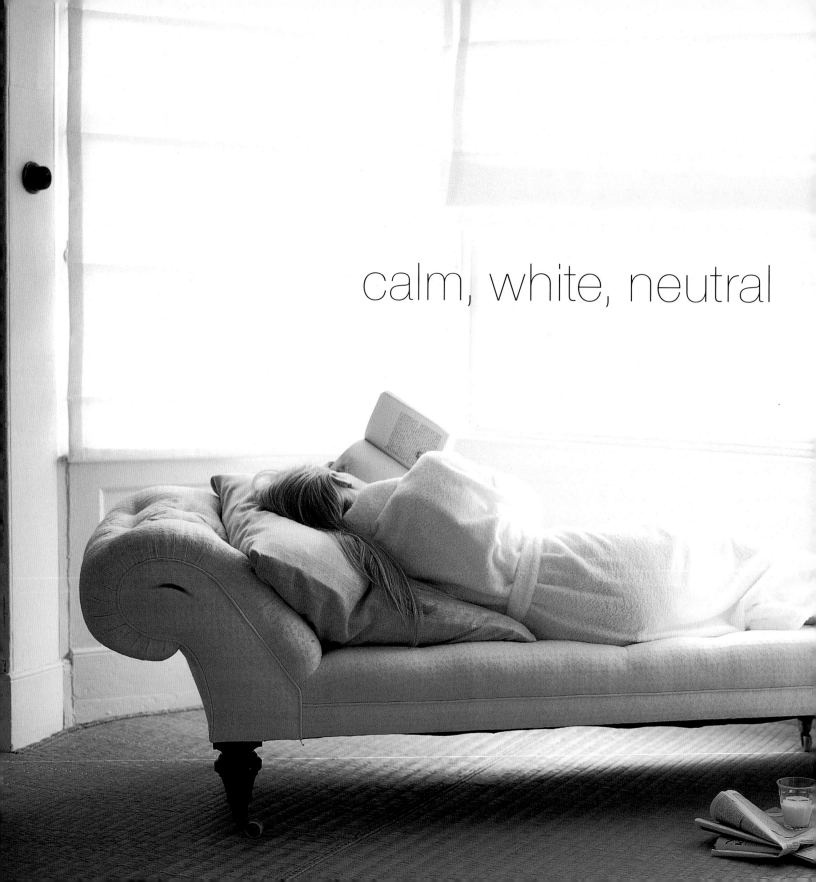

calm, white, neutral

Left **Relaxing with a good book,
close to a source of natural light,
and lounging on a comfortable
chaise lounge is the perfect way to
unwind and the ideal antidote to
a busy day crowded with color.**
Right **With their soft, cloudlike hues,
smooth worn pebbles gathered during
a day at the beach add a certain color
balance—the right choice of white in
a tonally rich bedroom scheme.**

Using the pale hues of sea-smoothed pebbles as a
starting point, this bedroom shows how combinations
of white on white are always clean and refreshing.

Every surface in this bedroom except for the floor uses a
variation on the white color theme. Leafing through a
book is a sheer pleasure in a room where wooden
paneling, Roman shades, and furniture are painted in
various tones of gray-white, bone white, and dirty white. The natural
matting of the floor breaks up the planes of white slightly, but is a
workable companion for white walls and wooden furniture. In
bedrooms that are not used much during the day, you can afford to
throw practicality to the wind and indulge more luxurious instincts.

White is always pure and appealing, a good way of neutralizing
crowded thoughts and busy decoration and making an interference-
free backdrop for paintings or bold furniture. Blinds rather than
curtains filter the light without destroying it and allow the
architectural elegance of paneled frames and shutters to stand their
ground. A bath, a chaise lounge, and a good book are all that are
needed to complement a stylish but tranquil ambience.

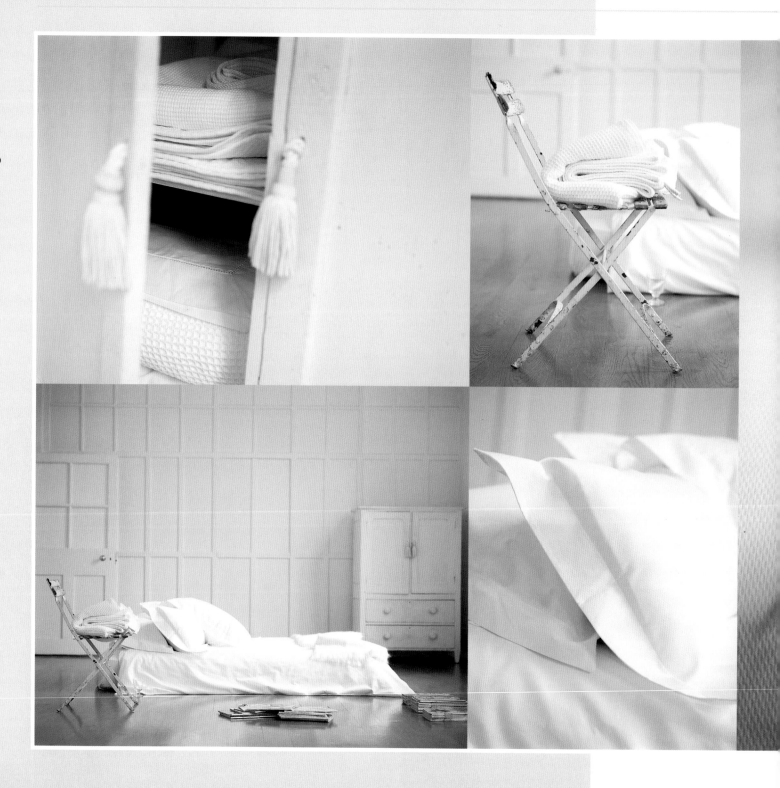

White rooms need visual definition of one sort or another. It may be a combination of white shades used over a variety of surfaces or an element of color relief in the form of wood or chrome on floors, walls, or furniture. Here, the precise simplicity is almost Oriental, the last word in understatement. At the same time, the play of textures and the almost imperceptible shift of shades of white on white make this bedroom an oasis of serenity. The well-proportioned wall paneling allows shadows to break up the large expanse of warm white, while the faded grandeur of the white paintwork on the cupboard is a satisfying foil to the sheen of the pale wood floor, so that the bed appears to float on a still pond.

However, for all its coolness, comfort is the keynote in this bedroom, with gloriously thick cotton pique bed linen offset by the sheer fluffy blissfulness of a creamy angora and mohair throw (**see picture on left**).

shades of vanilla

Far left (top) **Pure white tasseled door pulls on this linen cupboard indicate a soft, fabric-inspired approach to decorating with white.**

Far left (bottom) **An enveloping sense of tranquility and peace pervades this sleeping space where the bed linen is more important than the bed.**

Top center **A battered folding chair, which is casually laden** with a pile of soft white towels, is completely in keeping with the relaxed atmosphere of this bedroom. Covered with peeling white paint, it introduces a hint of darker tones in an otherwise all-white space.

Bottom center **Flat-bordered pillows with furled edges seem to invite the onlooker to rest among their folds.**

Strictly rectangular small-scale door handles on a randomly geometric run of tall kitchen cabinets are both stylish and ergonomic. The cabinets are sprayed a steely gray that is so low key it is almost white.

Below A quiet backsplash of pressed stainless steel merges with the stove. Accessories made from the same material sit effortlessly elegant on the shiny surface.

In a small kitchen with tall ceilings, this specially designed storage system is unobtrusive but effortlessly chic. White is always a success in small spaces, enlarging what is there and giving the opportunity for complementary materials such as stainless steel and chrome to bring light to the surfaces. The marriage of gray and white is a stylish one, producing a third hue that can be either pink- or blue-tinged, according to the natural light and the paint pigments used.

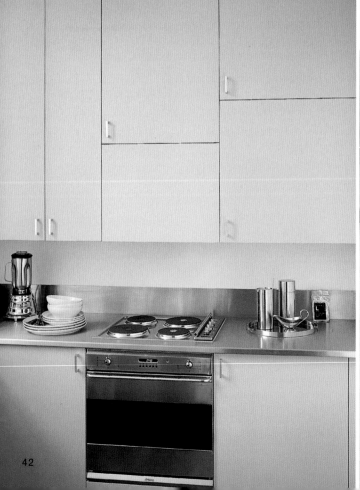

bleached beauty

Chunky and luxuriously matte, the glaze of these pure white Swedish ceramics has a subtle sheen that enhances the soft, satisfying curves of the china so that it takes on a sculptural significance when it is piled artlessly in groups on plinthlike shelves that have been painted bone white.

Another way of working in a restricted white palette is to introduce tones of the other neutrals—gray and black—as sharp definers, especially in rooms where the architecture has an inherent color pointer of its own. In this period room, iron window frames in black are echoed by small feet on the sofa and chairs and a wool throw edged with a single black line. In a room of unrelieved color, even slight details and careful changes of texture become very significant, shifting the emphasis away from the uniform.

When sleeping and living are combined in one room, with an adjoining bathroom, one color applied to all areas is a good way of enlarging the space visually and letting the color take second place by keeping it neutral and natural. White is useful for enhancing a space, allowing you to play with scale and create a color look with furniture, pictures, and fabrics. Alternatively, you may crave simplicity at all costs and use only neutral furnishings, finished off, as is the case here, with crisp linen pillows and a cotton rug.

natural linen

Linen throw pillows with a flat border and a graphic contrasting stripe are more than enough decoration on a simple white sofa.
Inset Defining the edges of a throw with coordinating gray and black fabric is a clever way of pulling together a muted and subtle color scheme.

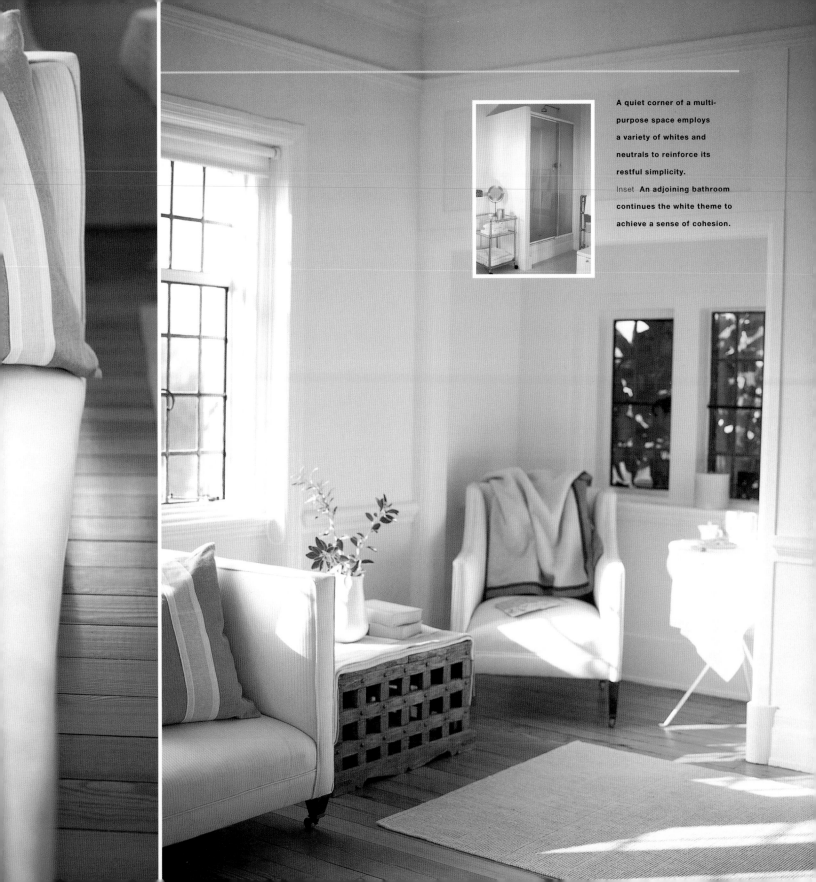

A quiet corner of a multi-purpose space employs a variety of whites and neutrals to reinforce its restful simplicity.
Inset An adjoining bathroom continues the white theme to achieve a sense of cohesion.

snow and ice

Below **White and glass aranged across two tabletops create a sense of effortless elegance in a dining room. The wooden dining chairs are the only color distraction from an otherwise restrained combination.**

Below center **An elegant vase of flowers makes a fetching contribution to a side table.**

Below right **A table laid in colors that merge with the room is always inviting.**

Top right **Well-polished silverware lies on soft napkins.**

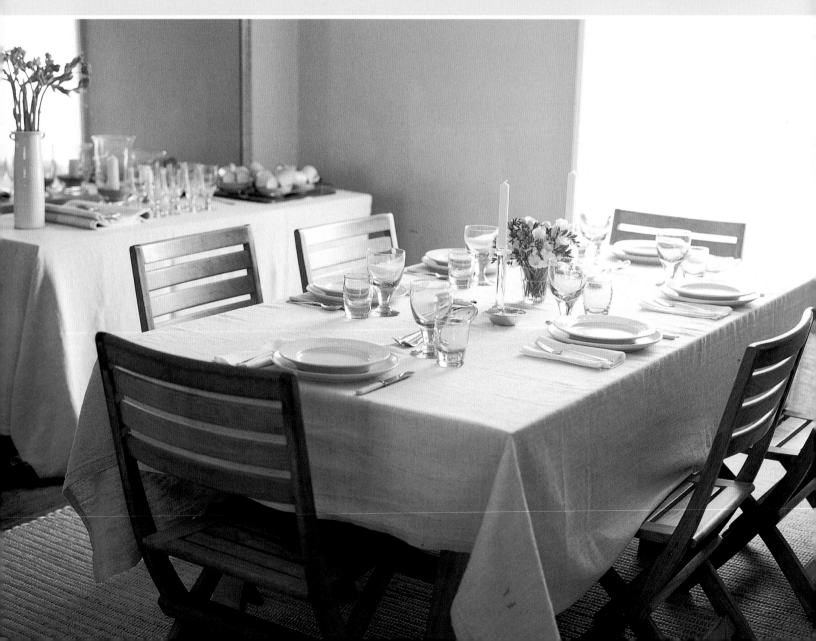

White can never be boring when it is put to work in a space as a bold orchestrator of tone, texture, and mood. Here, crisp linen tablecloths and napkins shout class. Draped over a dining table and side table pushed up against a huge wall mirror, the cool white and cream tones dance back and forth across a room where soft gauze at the window filters country light into the dining area. Chunky white Swedish china, generous thick-stemmed wine glasses, and antique silverware complete the sense of cool. The reflections of glass in and around the space create imperceptible shifts of light against the delicate greenery of white seasonal flowers.

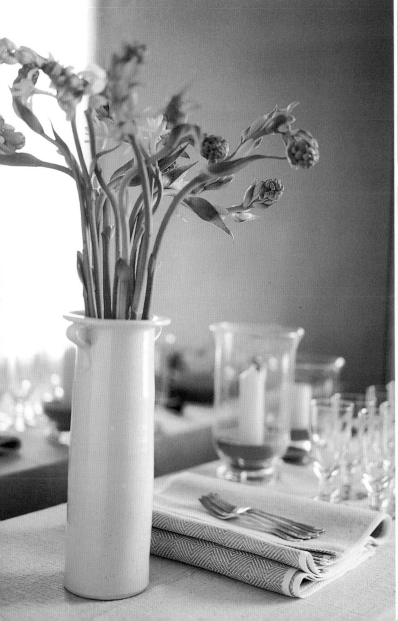

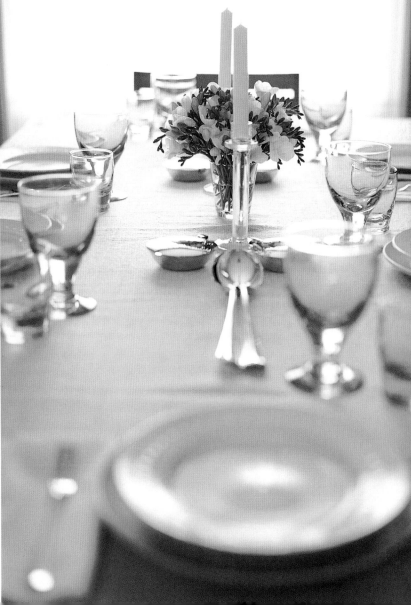

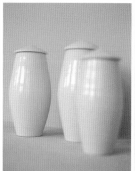

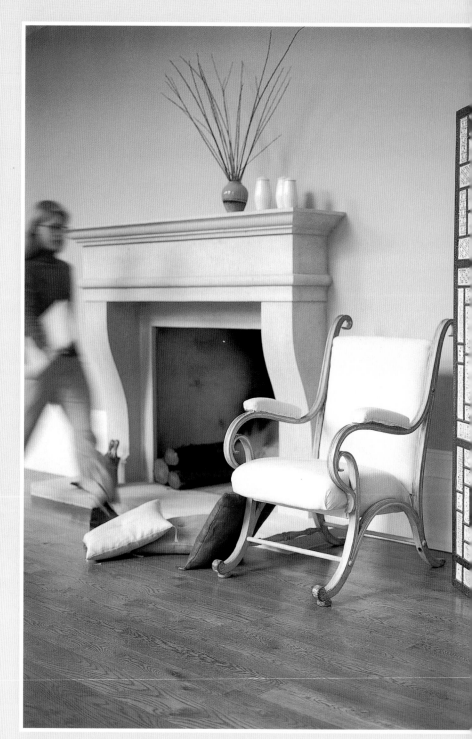

Above left **Use pillows as color definers in a range of shades that complement a room.**

Above right **Palest milky cream ceramics add that all-important textural element to a color scheme. The sensual surfaces of these ceramic vases are cool to the touch.**

Right **Delightful toffee-colored walls are both warm and subtle, allowing other colors to work around a scheme of wood and white.**

Far right **Pieces of furniture that combine textures and colors of the overall story always enhance a space.**

M ixing white with the darker tones of toffee, polished oak, natural canvas, and thick leather is a good way of de-neutralizing it and bringing some darker elements into the picture. Pale ceramics and upholstery will lighten the tone when the walls are a deep, interesting shade, while darker pieces of furniture will anchor white walls, pulling a scheme into cohesion. Wooden floors are almost obligatory in such a discreet, carefully considered combination of shades. If you think floorboards may look too stark and uncompromising, they can always be softened, brightened, or changed by the addition of a rug. For some, though, the changing wooden tones on floorboards are enough in themselves to bring a touch of sophistication to a room.

wild about wood

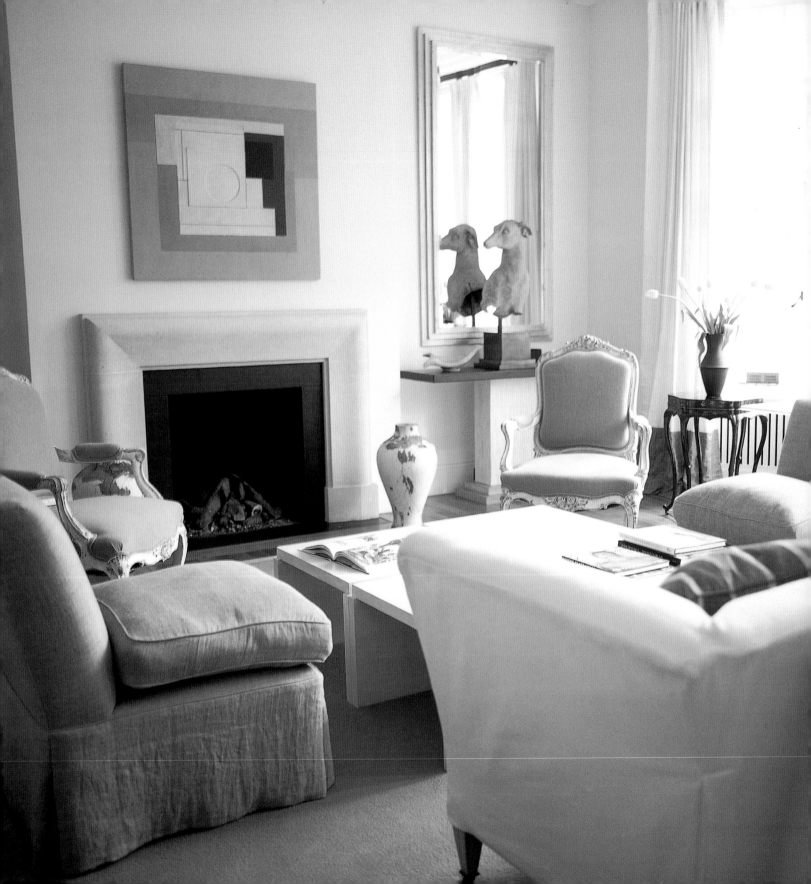

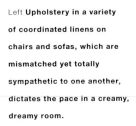

Left **Upholstery in a variety of coordinated linens on chairs and sofas, which are mismatched yet totally sympathetic to one another, dictates the pace in a creamy, dreamy room.**

Right **The art objects that have been dotted around this living room are large and bold but not too imposing.**

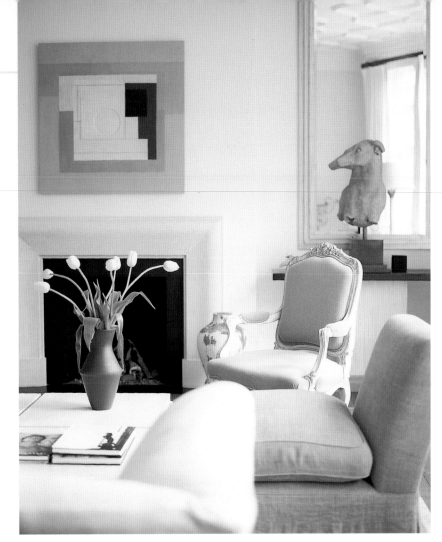

classic glamour

Using a subtle combination of wood, white, brown, black, and cream, this elegant living room pulls together fabrics that are sympathetic to one another in both texture and color. The carefully chosen furniture also combines classic elegance with a slightly modern aesthetic, while the walls seem to breed light and interest with a large mirror and striking paintings.

These paintings act as bold definers above and to the side of the chunky stone fireplace. Everything in this room suggests quiet understatement and elegance. Nothing shouts for attention, and yet the room calls out comfort and restraint. From the smooth surface and sinuous form of the large fire-side vases to the arching curves of the tulip stems in the vase, this room abounds with calm serenity.

Far left **A glass-topped table on sturdy trestles makes an understated workstation in a "cooler-than-thou" bedroom.**
Left **Crisp Egyptian cotton sheets and pillowcases with flat borders are always a joy, making stepping into bed a truly sensuous treat.**

Below left **Cashmere and silk can be relied upon to denote luxury at any time.**
Right **A sumptuous bed throw and an antique ottoman, which has been upholstered with a luxurious finish, give this fantastically subtle bedroom a sense of vitality as well as decorative punctuation, pulling it away from the discreet to the stunning in two easy moves.**

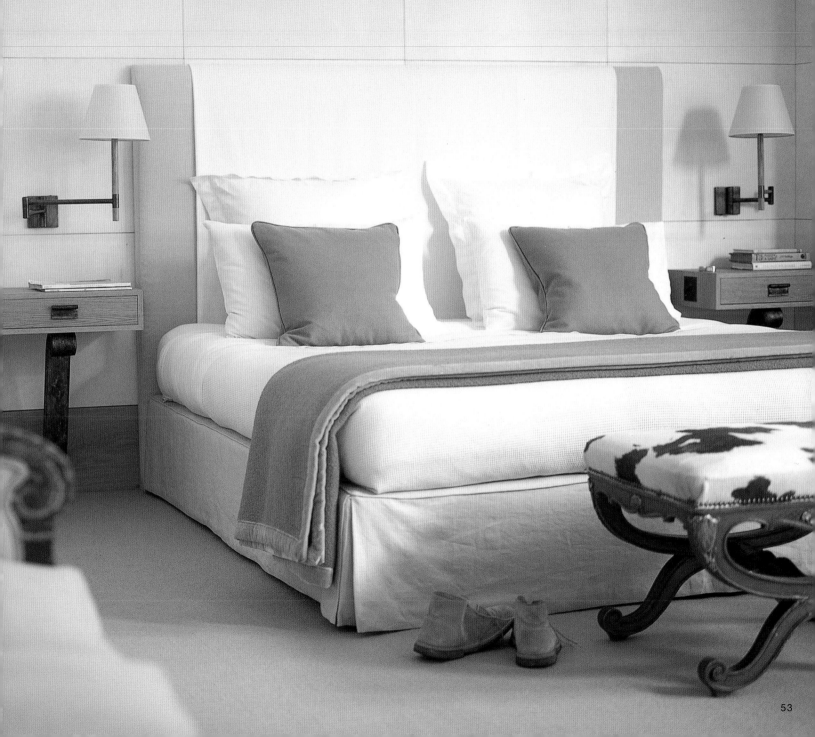

raw silk and cashmere

"Rich brown is the color of good things."

chocolate, amber, & silver

One step away from a totally neutral color grouping, the combined colors of chocolate, amber, and silver tell a sophisticated story. A rich textural mix of earth tones, with accents provided by chrome gloss can shout class and elegance. These colors recall the coffee house, which comes to life in a rich conglomeration of cappuccino browns and thick creams, topped with a frothy silver sheen. Such colors are also synonymous with the natural elements of earth, wind, and fire.

Brown has been a much underrated color for several years, but it is basking in a well-deserved revival now that the 1970s have been redefined for a post-ironic generation. Brown is once again an exciting tool. Just think of pure dark chocolate, luxurious butter toffee, and a fine cup of swirling caffe latte, and you will see how comforting these lush, warm colors can be. They can also provide clear contrasts when they are highlighted with creams and milky whites.

"A rich textural mix of earth tones with accents provided by chrome gloss can shout class and elegance."

The middle-range browns, in particular shades of toffee or toast, can be warm or cool, depending on their tone, but are definitely calm, subtle shades to work with. Earthy brown has been used in decorating since the very earliest times. Natural pigments such as raw or burnt umber mixed with whites produce rich, deep tones of brownish-black. The Victorians in particlar loved brown. Their rooms were full of rich mahogany furniture, deep brown woodwork, and wood-toned curtains and fabric. William Morris, too, the Victorian designer and craftsman, worked extensively with brown, and it is often a strong feature of his fabric designs. The Modernists employed brown on a small scale, as a foil for white, while Charleston, the country retreat of the British Bloomsbury group, boasts many shades of earthy brown in Duncan Bell's swirling painted patterns on a variety of surfaces.

"Leather is a fantastically versatile material."

Natural associations within the brown spectrum include the warmth and dense texture of animal fur. Nothing tells you more about the subtlety of changing tints and tones than a Burmese cat sprawled on a deep pile rug or a Jack Russell terrier whose wiry deep ebony coat merges into swirls of rust, toffee, and dirty white. Fake fur also has a role in a brown and neutral scheme. Leopard skin, zebra, and cowhide all lend contrast as well as warmth to a scheme. Leather is a fantastically versatile material. Smooth when new, it ages into a pitted but pleasing surface after years of wear. A battered leather armchair seems to display its life history with pride; pock-marked arms and scratched cushions are all part of the charm of such informality.

It is a good idea to use deep brown in rooms that already have an adequate supply of light and need to feel cozy and secure, or in rooms that are most frequently used in the evenings. Living rooms and bedrooms in particular often carry off brown schemes well. Strong brown is a good foil for vivid or pale turquoise and pink, while the lighter caramel tones are a sophisticated complement to whites and creams. Psychologically, brown is linked to a need for security, a desire to establish connections with likeminded people, and a yearning for comfortable surroundings. Think of a Victorian snug with wood-paneled walls and frosted glass for a clear understanding of the complete effect that can be achieved.

"The coffee house comes to life in a rich conglomeration of cappuccino browns and thick creams, topped with a frothy, silver sheen."

Wood, particularly dark woods such as teak, mahogany, and cherrywood, is all-important to this color scheme. Smooth mellow tones and subtle patterns merge easily with neutral upholstery and the instant gloss of chrome studwork or ethnic metals such as Mexican tinware or Indian metal beading. Dark wood paneling never fails to be cozy and welcoming, while ornately carved benches, seats, and tables bring an air of confident solidity to any room, whether it be traditional or contemporary. The sheer divergence in pattern and tone is a constant inspiration.

Amber as a color encompasses the orange-biased earth shades, from terracotta to pale peach, and a wide range of shades in between. Often produced by mixing siennas and ochers with other colors, this warm orange-red mixture blends easily with the brown-related umbers to produce pleasing earth tones that are a shade or two removed from the coffee-house hues. These colors are more terracotta than chocolate. The amber spectrum is a delicate series of tones that are highly reactive to changes in light. It is worth experimenting, therefore, before consigning a soft orange or terra cotta to a wall. The color will change almost by the hour, according to the natural light supply in the room.

orange-red mix is soothing and strong without the overkill of lurid tones of either orange or red. Amber, or terra cotta, looks good in kitchens and living rooms where inviting color always succeeds. Juxtaposed with silvery blue tones in the form of stainless steel, chrome, blue-gray paint, or frosted glass, it assumes a life of its own, bouncing the light off smooth surfaces and throwing it back onto the rich earth tones, bringing an

"Metallic finishes provide good definition."

"The sharp glow of a metallic surface against pure earth is a happy juxtaposition."

extra warmth with it as the color density is broken up. It is interesting to note that this particular combination of colors has been found in ancient Egyptian frescoes and early cave paintings.

Silver is more often about texture and finish than color. Think of stainless steel, chrome, zinc, and punctured tin, all reflective surfaces that provide a glossy edge to the more solid earth tones as well as elegant sheens that bring life to dense patches of color. The sharp glow of a metallic surface against pure earth is a happy juxtaposition

"Stainless steel, chrome, zinc, and punctured tin"

Amber is a warm color. In color preference tests, orange diluted until it reaches a peachy tone is the most universally liked color by both men and women. Yet it can be tricky to achieve a tone that does not swing too far either way between orange and red. Restful but stimulating at the same time, some people cannot stand to see orange tones in any form, while for others it lifts the spirits. A good

that can be exploited in many ways. Bathrooms, with their abundance of chrome surfaces, call out for terra cotta and brown as companions for all that shiny cleanliness, as do kitchens. Used as detailing on picture frames, furniture edging, and on occasional tables, metallic finishes provide good definition and contrast to the looser, more natural colors of the group.

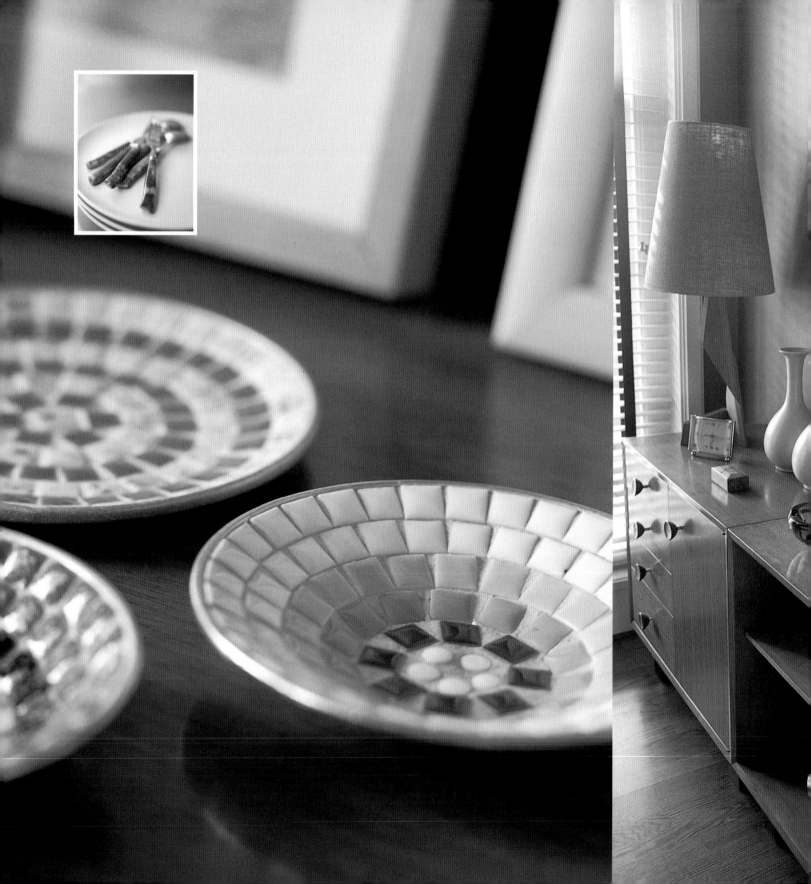

n a glorious remake of the 1960s and '70s, this urban apartment twists the style a little to embrace a world view. In the dining room, the mix of furniture-design classics and junk shop pieces is part of a scheme that is pure brown in color and quintessentially 1970s, yet also incorporates elements of the international airport lounge aesthetic. The use of shape and texture to complement the colors is masterly. Taking historical color themes and updating them with accessories and quirky furniture is an interesting way of reinterpreting the past for a contemporary setting without creating a museum of hackneyed taste. People move on.

Here, in the dining room, a wallpaper remnant in the signature '70s colors of brown and pale orange is mounted as a piece of artwork, an ironic decorative statement in a room that has otherwise

continued on page 63

hot chocolate

The sculptural curves of contemporary furniture feed off a chic palette where soft browns and chocolate combine with all the appeal of a perfect cappuccino.

Far left **A simple geometry pervades this room as circles within circles keep appearing on the ceramic mosaic ashtrays and on chunky Swedish dinner plates (inset).**
Left **This wall hanging continues the geometric theme while the shadows cast by the blind onto the lampshades create a similar pattern of concentric circles quite by chance.**
Right **Family photographs and a set of framed originals provide a neutral backdrop for an amber ashtray.**

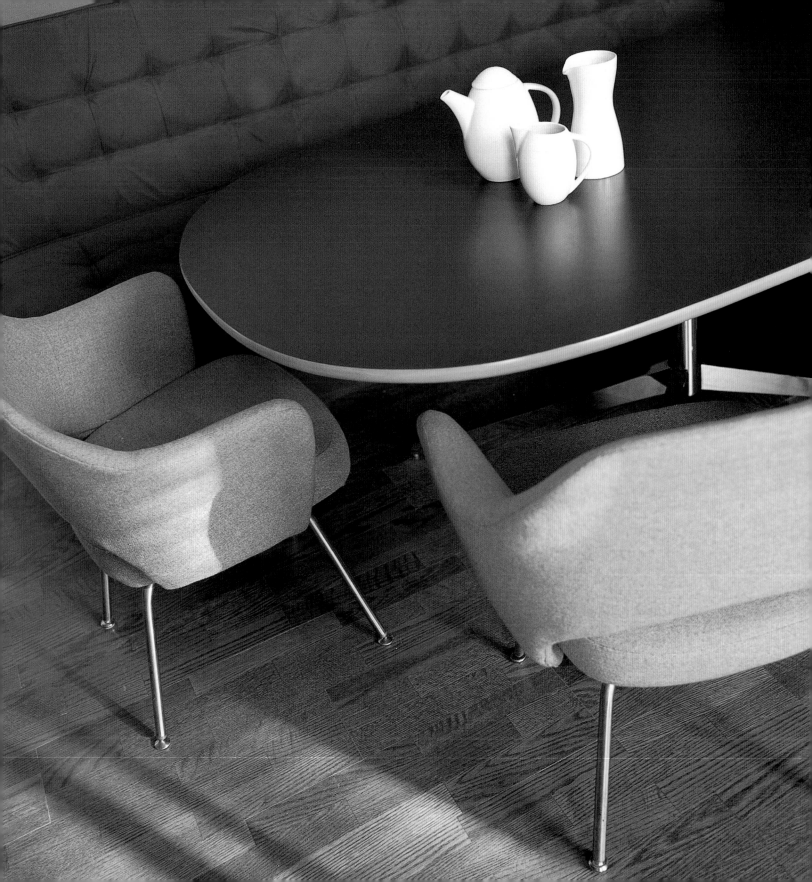

plain walls the color of melting chocolate. A Knoll
International design piece sideboard is complemented
by two table lamps with orange burlap and a collection
of 1960s mosaic ashtrays.

The dining area is an exercise in combining
cappuccino tones to create a delightful play of tone
and texture. A deep-buttoned banquette is upholstered
in a slinky grayish-brown synthetic material and forms
a strong band of color between the deep matte brown
of the walls and the high-gloss laminate of the table,
like blocks of chocolate, coffee, and mocha melting
into one another. The paler flecked wool upholstery of
the chairs, in shades of biscuit with just a flash of
steel leg, stands out against the deep sheen of the
dark woodblock floor. An elegant, sensual Florence
Knoll leather daybed is placed by the tall windows so
that soft slashes of daylight slice through the gray
metal Venetian blinds to play delicately over the
inviting curves and recesses of its surface.

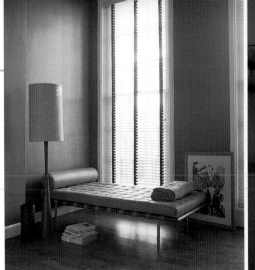

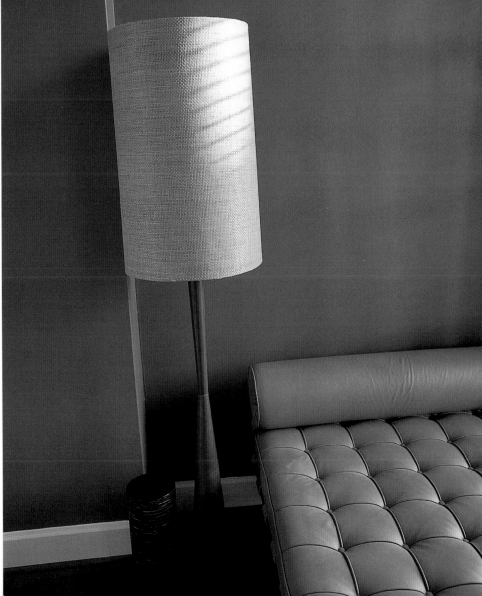

Left **With a color scheme
based around brown and gray
and an atmosphere that is
ultra-hip, this room is a space
in which the airport lounge
meets high design. To use a
musical analogy, the tonal
palette calls to mind a
successful jazz improvisation,
the browns and grays
blending effortlessly into one
another rather like variations
in a deeply satisfying melody.
The words best used to
describe this decorative
ensemble are mellow, cool,
and very sexy.**

This page, top left **Almost an
altar to cool, this original
version of the Florence Knoll
daybed is placed enticingly
near the window—the ideal
spot for leisurely reading or
gazing idly out of the window.**
Top right **Gray, brown, and
amber on the chairs, the
table, and even the vase make
up the constituent colors of
this dining-room scheme. The
sweeping sensual curves of
the table and chairs also add
to the air of utter relaxation.**
Right **A floor lamp stands
guard in this temple of luxury.**

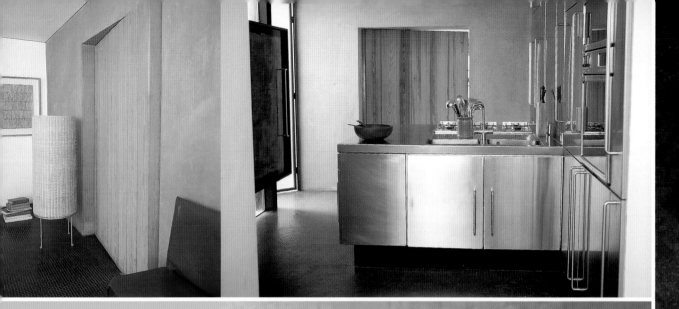

terra cotta, honey, and steel

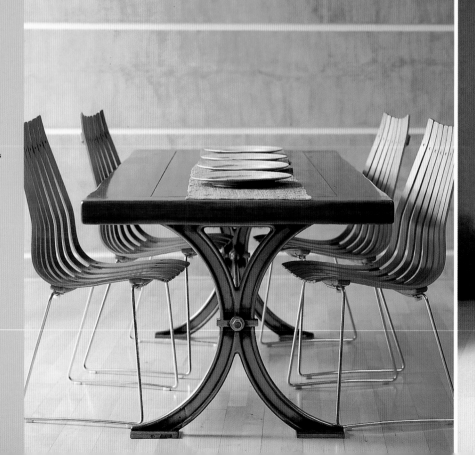

Above left **The color of these raw but rich terra cotta walls is achieved by painting on a thin coat of pale orange, then applying a diluted colorwash of palest pink.**

Above right **The pleasingly sophisticated sheen of steel countertops and tall cupboards is played off against raw, almost unfinished-looking terra cotta walls.**

Right **Bold horizontal planes of wood painted to resemble the pleasing irregularity of cowhide are a stylish alternative to plain, plastered, or papered walls. Flirtatiously elegant chairs make sinuous curves at an otherwise solid and rather severe-looking table setting.**

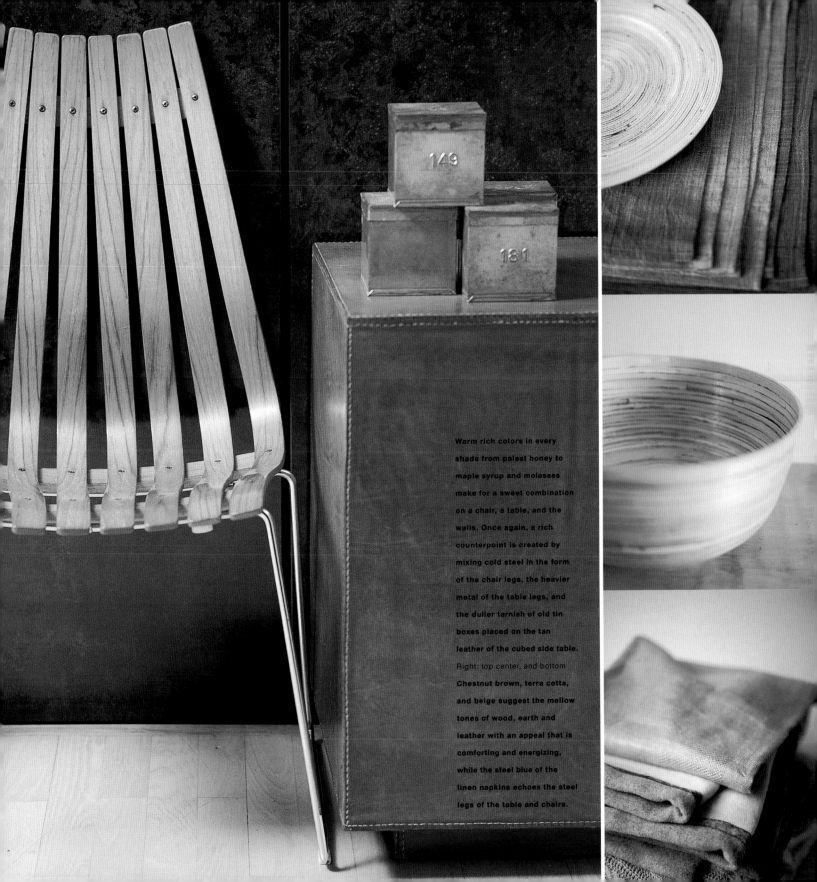

Warm rich colors in every shade from palest honey to maple syrup and molasses make for a sweet combination on a chair, a table, and the walls. Once again, a rich counterpoint is created by mixing cold steel in the form of the chair legs, the heavier metal of the table legs, and the duller tarnish of old tin boxes placed on the tan leather of the cubed side table. Right; top center, and bottom Chestnut brown, terra cotta, and beige suggest the mellow tones of wood, earth and leather with an appeal that is comforting and energizing, while the steel blue of the linen napkins echoes the steel legs of the table and chairs.

M ocha, that wonderfully elusive color where darkest bitter chocolate almost becomes rich black coffee, comprises dark tones that drift around one another like bass notes in night music. Add just a dash of cream and you release a whole color sample card of delicious, barely discernible hues, from cocoa bean to oyster. Think of the velvety shifting tones on a Burmese cat or the light shading on its paw or ear tip, and you will see the most effortlessly elegant of color schemes. These are colors that don't need to impress; they just know they are pure class. Treat them as they deserve and allow them to languish on quality materials. They are, for example, at their most seductive when used on fine leather and suede, the heaviest of silks and linens, velvet, chenille, and fur—fake, of course. These mocha shades emanate naturally from exotic hardwoods, such as ebony and mahogany, and look equally handsome in a flat waxy finish or a glossy lacquer.

Top right **This bed is dressed in soft putty-colored linen, edged in broad panels of dark brown and deep charcoal gray that almost crosses over to midnight blue.**

Center right **A deep pile of luxurious leather cushions and a soft chenille throw seem to**

vibrate with mellow, moody, mocha tones.

Bottom right **Chocolate nonpareils combine the shine of ebony with the richness of chocolate brown.**

Far right **A color of this strength needs to be framed by soft, light cream shades.**

mocha moods

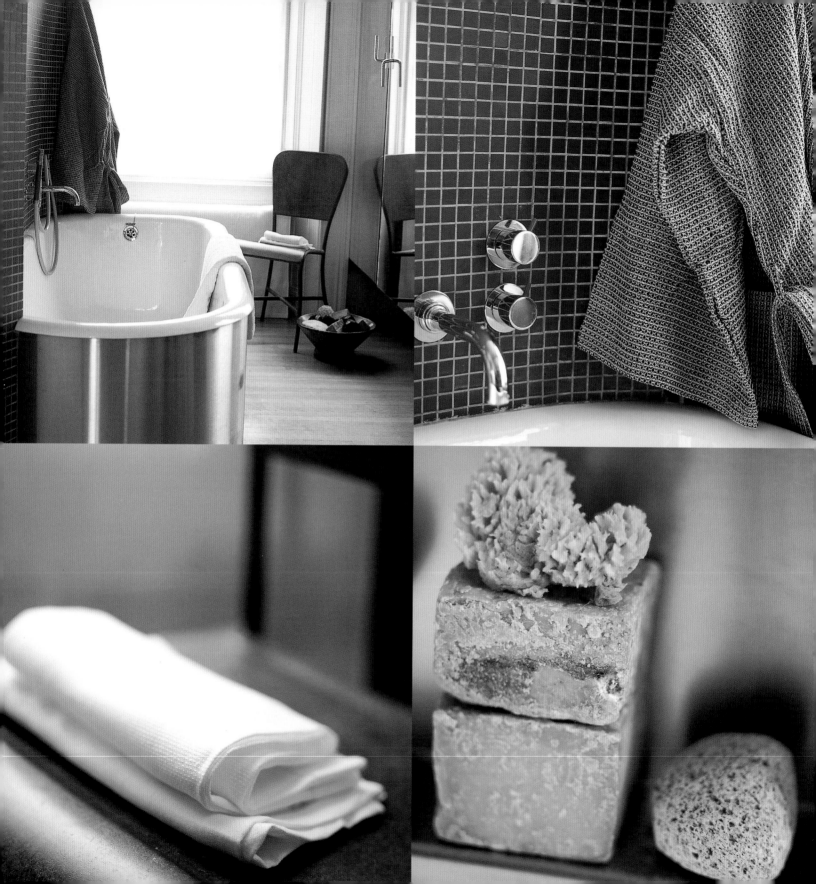

Far left top **A simple sheer white blind allows daylight to bounce off the mirrored doors and the pale wood floor to dance on the lustrous sheen of the stainless steel bathtub.** Center top **The gray tone of a waffle-weave robe is at one with the mosaic walls.** Far left bottom **Crisp white linen towels against the rusty patina of a curvy metal chair lend purity and texture.** Center bottom **The pitted, chalky gray and black speckles of pumice stone accompany chunks of dun-colored vegetable soap and a natural sponge in a decorative story that owes as much to texture as it does to the colors black, gray, and white.** Left **A smart sophisticated bathroom, which has a slightly masculine air at first sight, is taken beyond such obvious assumptions with the addition of tiny, slate gray mosaic ceramic tiles on a wall plinth. This divides the bath area from the sink and shower. The result is a richly satisfying union of textures and earth tones that provide a refreshing warmth and a tactile appeal.**

stone and steel

Above left **The earth tones of the wooden benches and pottery in this predominantly steel loft kitchen are an understated nod toward the spice world.**

Below left **Delicate chocolate truffles reveal their crumbly texture and provide a source of ideas for using deeper chocolate tones to temper the spice.**

Above right **A soft tawny glow emanates from the deep pinkish-amber walls of this peaceful living room. The slate gray stone floor with its intriguing pebble inserts works particularly well in this scheme.**

Below right **A delightfully cozy corner is a triumph of "no-color" decorating, all the colors here being intrinsic to the natural materials used—rich nut brown leather, honey-toned pine, and dark stained oak.**

Far right **Spiced clove balls piled in an inlaid wooden bowl make reference to the spicy inspiration of the room's colors. The walls are washed in a muted cinnamon and the furniture in the Vandyke-brown of cloves and vanilla pods. This fragrant mix is tempered by the cool vanilla upholstery striped in gray.**

cinnamon and cloves

Rare spices are, rather like precious substances, a special treat to work with. The very words amber and tortoiseshell, ebony and horn, gold and bronze as well as cinnamon, nutmeg, anise and saffron are enough to conjure up evocative images of spice routes and trading in distant hot countries. Aromatic and exotic, these colors travel well, creating a heady and enticing mix with which you can create pure decorative magic. More potent and intense than any other natural colors, they need to be handled with care if you don't want to feel as though you have strayed into the kasbah. At one end of the scale there is orange; at the other, the rich earth shades of ocher, verging on antique pink.

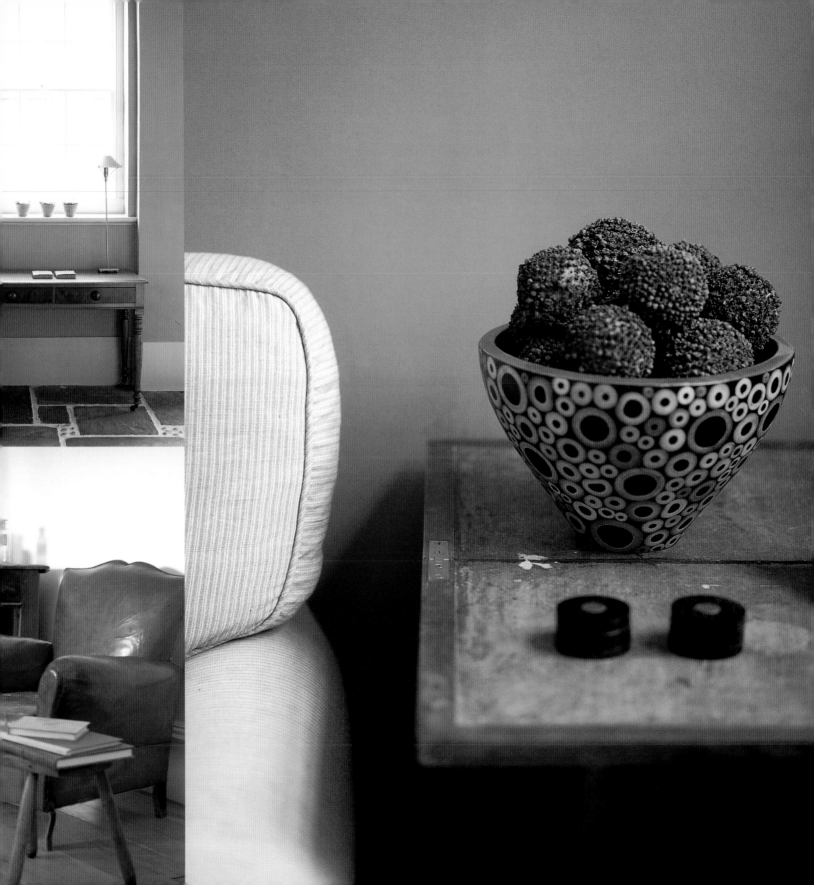

"Undeniably pretty, soft pastels have a melting subtlety when used with restraint."

ice cream, sherbet, & biscotti

The soft pastel colors of ice cream are enough in themselves to transport you to another, more glamorous age. Unashamedly beautiful, feminine, and elusive, the delicate shades of old rose, eau-de-nil, champagne, ivory, coral, lavender, tea rose, celadon, and duck's-egg blue are reminiscent of the 1920s, when pale tones of biscuit, cream, and shell pink were signature colors. This was also a time in fashion when silk stockings, bias-cut tea dresses, satin dressing gowns fit for a movie star, and shimmery eiderdowns were the must-haves of the day. The luxuriousness of these colors was sheer bliss.

Such soft colors are most at home luxuriating together in a cool harmony. Blended shades of taupe, chocolate, and salmon can be

"Pastel colors work best when they are at their most elusive and indefinable."

insipid if viewed alone, but used together and delicately balanced in a muted fusion of tone and intensity, they will produce varying degrees of strength and light that are sophisticated, slightly feminine, and utterly alluring. These elusive shades are particularly suited to soft furnishings, so experiment with soft textures and tones on the fabrics of curtains, pillows, throws, and upholstery, which provide the surfaces on which these subtle hues play off one another. The overall tone of these colors can also alter as the light changes throughout the day. Think of the subtle sheen of raw silk, the incandescent shimmer of taffeta and satin, and the fragile translucence of voiles and sheers, and you will see just how successful these colors can be when they are used in association with certain fabrics and textures.

By combining these undeniably pretty colors with more sophisticated neutrals, you add an extra dimension to both colors. All shades of lavender and mauve look wonderfully elegant when partnered with silver-grays and gray-greens. Yellow-pinks assume a melting subtlety when used with fawn, biscuit, and beige, while the palest primrose yellow is best taken back to its earthy, woodland roots and mixed with

deeper peat browns, stone colors, and mossy greens. Pale powder blue loses its babyish connotations if you consider it in terms of a soft blue bird's egg, speckled and encircled with the cool, grayish brown feathers and twigs in a rough nest.

Pastel colors work best when they are at their most elusive and indefinable. Think of the palest aquamarine seeping into the pale gray-browns of a seashell or the gentle brownish-pink of a mouse's ear and you realize how potent the effect of these colors is, even on the smallest scale. Often dismissed as too girlish for serious interior decoration, these sugared-almond colors need elegant handling to prevent them from straying into a sickly sweetness. But if they are used with restraint, they impart a fresh quality, one that creates color schemes to genuinely soothe the soul and please the eye.

Ice-cream colors are forever associated with the most happy times in our lives. They make us recall the colors of weddings, baby clothes, ice cream, candy, ballet shoes, and birthday cakes. Although these colors are symbolic of all that is fresh and new, from spring flowers and apple blossoms to rosebuds and the health of a child's skin, it is still easy to see how all this sweetness can turn to syrup when set against the mundane practicalities of everyday life.

"Sugared almond colors need elegant handling."

The key to using soft pastel colors is to be quite severe in the shape and texture of your furnishings, because these can serve as a foil to the gentleness of the colors. Choose the plainest of curtains and blinds—luxurious in fabric and generous, if you like, but no swags and ruffles. Instead, choose simple drapes that hang gently over steel poles or tie loosely onto wooden dowels. Opt for undecorated, unadorned bed linen and upholstery quasi-utilitarian shapes for chairs and sofas, clean-lined furniture, and the purest of ceramics in order to make simple statements. Avoid creating the impression of a dollhouse at

"All shades of lavender and mauve look wonderfully elegant partnered with silver grays and gray-greens."

and inviting, never quite pushed to a permanent extreme. It is wise to experiment with it before deciding if its pale tones of red and blue make it more than the sum of its parts or an unsuccessful and unsettling compromise in a shared space where reds and blues are fighting for domination but are being forced into co-operative submission.

Biscuit tones can encompass the waferlike hues of ice cream cones, sugar-topped cookies, and chocolate cream. The semineutral shades of caramel and banana used on woodwork, upholstery, window dressings, walls, and floors are calming and reassuring colors that will provide a gentle background for the other, stronger pastels.

all costs, and you will find you have arrived at a combination that is particularly satisfying. Aim for restrained indulgence that is sweet yet sophisticated, alluring rather than innocent: a recipe for happiness.

Decorating with pink is a question of creating a delicate balance between whimsical romance and fuchsia overload. Think about the scumbled texture of raw plaster and you will notice that good pink is,

"Ice cream for indulgence, sherbet to refresh, biscotti for tone"

in fact, a charming collection of light lilacs, fleshy skin tones, and slate greens and grays. Pink works better as a backdrop rather than highlights on accessories, where it can assume insipid hues. Tones of shell pink are especially pleasing in bedrooms and bathrooms if you want to create a clear, calm atmosphere. Shades of plaster contrast nicely with stainless steel in kitchens and lend a gentle warmth to living rooms if combined with soft blues, biscuit shades, and palest grays.

Lilac is another elusive color that shifts tones effortlessly throughout the day, according to where it is used, looking pale blue one minute, palest gray the next. Although labeled a "pretty" color, lilac is often striking used over a large area such as a hall, stairs, and landing, where the shifting shadows cast by natural light make its changing shades dance. Combined with white detailing in bedrooms, it also plays intriguing color games, since it is neither strongly directed in one or another primary direction. Lilac is at once cool and warm, cold

Tones of cream, milk, and biscuit are usually the basis of the most-successful color stories where a light-enhancing backdrop may be needed to overcome the dim orientation of a room or home. Instead of leaping in with strong primaries, dark mahogany-toned wood detailing, or bright, Mediterranean, sunflower yellow and acid green, allow the new subtlety to encroach upon your perception and think about the less saturated shades in a room where light should dominate. You may find yourself overwhelmed with a satiny romanticism that dictates chic ice cream, tea-dance pink, and walnut veneer all thrown together—a measured hint of the past for the modern home.

"The key to using soft pastels is to be severe in the shape and texture of your furnishings as a foil to the gentleness of the colors."

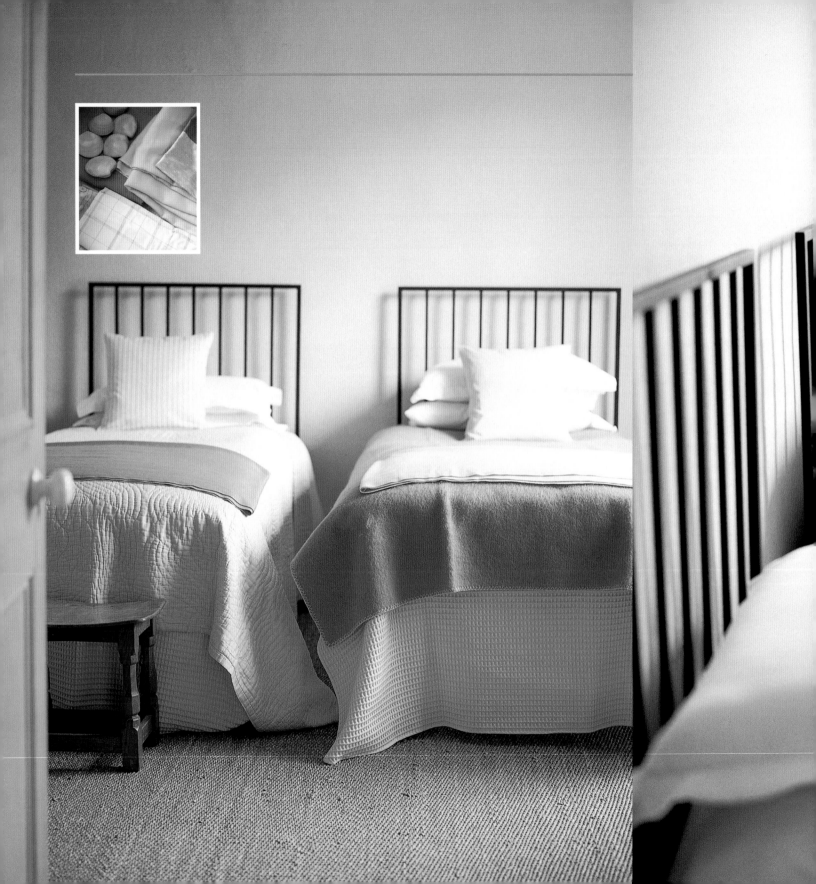

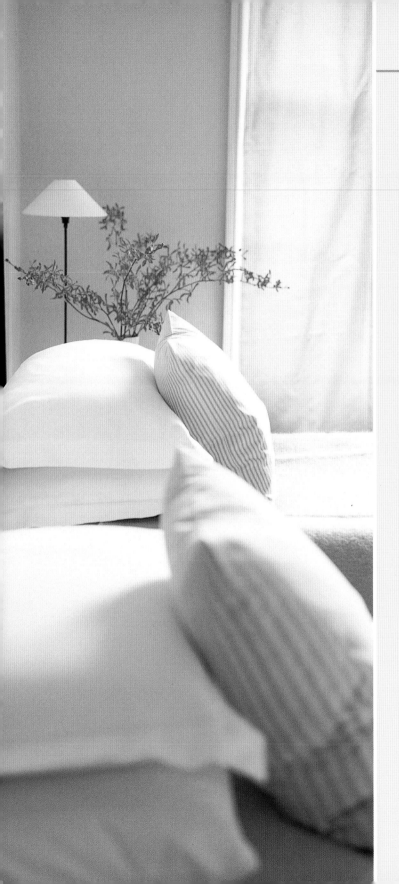

Feminine but punchy, the ice cream colors in this bedroom turn casual understatement into an exercise in restrained elegance.

pretty in pink

Pink often finds itself confined to bedrooms, shyly parading as a half-color and not allowed out into the public domain where both sexes have to decorate according to a mutual color code. But pink doesn't have to be overtly feminine or frilly, as this pared-down bedroom proves. Here, rectangular metal headboards provide a graphic quality that prevents the color from dominating the room. The only truly delicate elements are machine-quilted throws and bedspreads in textured cream that give a hint of the rural location of this house. Warm toffee-toned blankets are used as a highlighter, while a shimmering, salmon silk window banner offers a red filter to the daylight as well as a whisper of luxury. Pink and white is really a more muted version of the classic red-and-white color combination, so they always produce a pleasing counterpoint. Flowers, too, can be used to provide a rich splash of pink in a room, resonating against walls of light caramel or cream.

Far left **Twin beds, side by side, are highly inviting for anyone passing.**
Far left inset **Pink shells and old linens sit well together to form a subtle story.**
Left **Generous, well-plumped pillows with cases made from crisp cotton fabric with candy-pink stripes kindly beckon the onlooker.**
Left inset **Headboards are important for calming or enhancing soft or strong colors.**

Above **A fabric-covered headboard makes a comfortable and appropriate backdrop for a bed that is tastefully dressed with lemon and cream cotton-covered pillows and a striped mustard throw that is draped invitingly across the foot of the bed.**

Right **Coordinating the curtains and throw pillows is one way of bringing a controlled splash of color into a room.**

Far right top **It is the personal little details you can incorporate that make all the difference when you sew your own furnishings. The family cat certainly finds this bed relaxing and inviting!**

Far right bottom **The sharply curved wooden frame of an old chair curls back on itself like a pair of ram's horns, capturing a soft cream mohair throw en route.**

The vanilla range extends from pure white sherbet to the buttercup tones of dairy ice cream. It can be employed as a soft yellow wall color in order to lighten darker rooms or used on fabrics to guarantee an enlivening experience. Here, the neutral ground gives way to delicate shades of lemon- and cream-striped textured linen at the window in the form of banner curtains on a wrought-iron pole. This pivots shut at night but hangs shutterlike in the day, framing the view.

Creating a scheme with fabric is a versatile way of making seasonal changes in a room. In a bedroom, simply re-cover the headboard, swap the throws, and keep a spare pair of simple curtains or blinds for a complete transformation when the mood or season sets off an urge for a new color, a different look, or even a radical rethink. A total makeover might include reupholstering chairs and stools, buying or making bed linen in a completely different style from before, and recovering pillows. Keep a collection of favorite fabric swatches and magazine clippings, perhaps sub-dividing them into seasons so you can easily find inspiration for a seasonal variation that you may want to introduce into a room. You might also like to start a file of whole color schemes that move and inspire you. In a room where the fabric does all the color work, you can manipulate surfaces and textures to quite a degree with a careful juxtaposition of furniture and accessories. Often it is the little details that create the main impact in a scheme.

soft mimosa

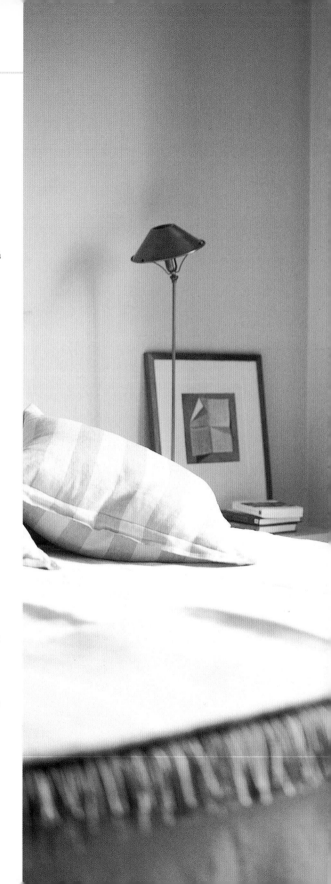

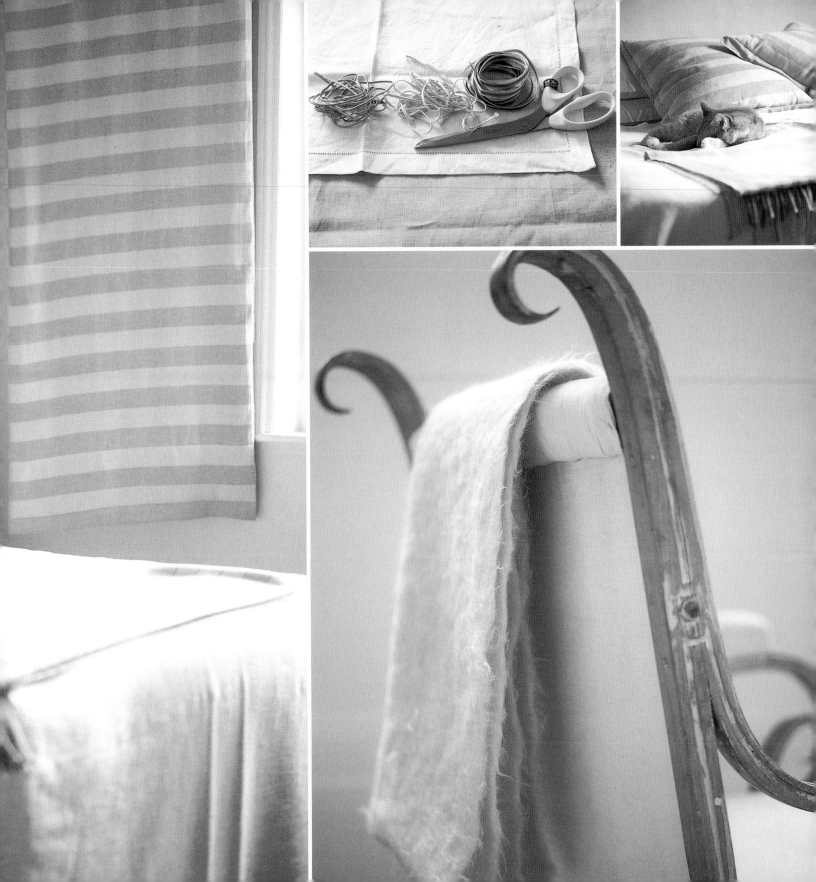

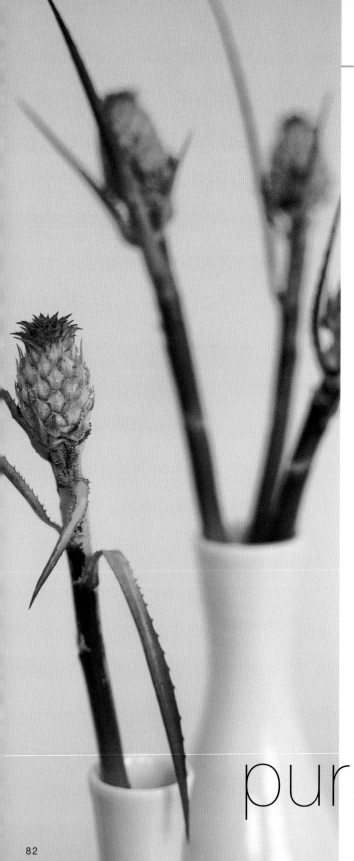

ight purple and lilac have not always been obvious choices for interiors but, recently rediscovered in tones of pale mauve, sweet-pea pink, and ballet-taffeta satin, they are once again contemporary and spare, elusive but powerful. Treated with care and used in the lighter part of the spectrum, they are spectacular, space-enhancing, and light-providing colors, with a soft delicacy that is subdued but malleable.

Think of nature and the way that lilac (both pink and white) and purple are often found on flowers and stamens, acting as visual punctuation against green leaves and blue skies. Part of the spectrum that lies between red and blue, these colors are good partners for white and for greens that are bright or muted. Try mixing them with pink to achieve tonal sympathy and a quiet spectrum.

Essentially spring and summer colors, the lavenders and lilacs breathe light into dark spaces and a hint of sunshine in light ones. Although usually regarded as feminine colors, they are actually sharp, smart colors when used in large planes such as on walls, on curtain fabric, and as upholstery. Cheerful yet slightly mysterious, at times intangible, they are not for the tame or unadventurous decorator. Here, a soft lilac on the walls is a quiet way of bringing a scrubbed wooden floor and simple furniture to life in a soothing mixture of sharp lines and soft color.

Left **Spiky thistle-like ornamental pineapples stand proud in solid, matte, narrow-necked vases. Using flowers as visual punctuation is often enough for a room of indeterminate hue to make a positive color statement.**
Right **Simplicity of style and luxurious fabric marry well. Delicate silk in a translucent pink is used here for slipcovers on unremarkable utilitarian chairs. The effect is a wonderful combination of form and decoration.**
Far right (top) **Flowers define and soften simply furnished rooms and make powerful points in their own right. Painted shelves are used for color-related objects and appealing books.**
Far right (center) **White-painted furniture, shelving, and baseboards smarten an already slick wall of pale lilac. The effect created by this room is light, refreshing, and spring fresh.**
Far right (bottom) **Don't forget the details. Even these pink matchheads in a bowl blend exquisitely into the scheme.**

purple haze

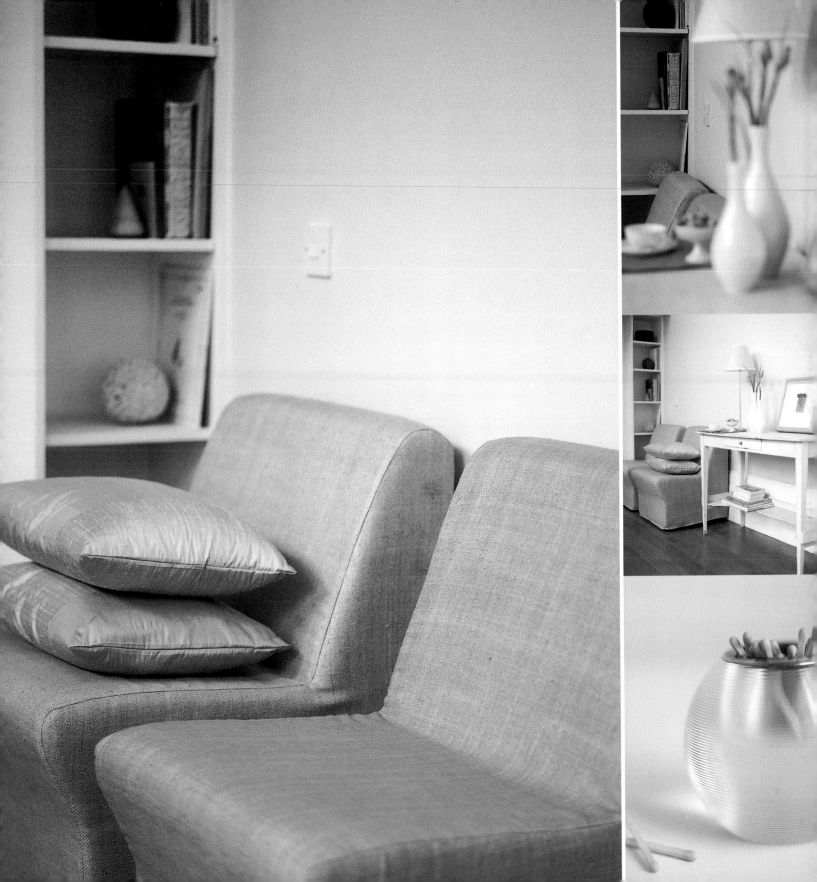

lilac light

L ilac is hard to pinpoint on the spectrum because it can jump from being almost silver gray to slightly pale blue, depending on the light. It is this versatility that makes it ideal for use in spaces where sunlight or natural rays play with it throughout the day, creating shifting hues and pleasing shadows within a room.

However, such an interesting color need not be confined to walls. Tables, ceramics, upholstery, and even displays of fine sewing threads all look effective in lilac. It works best placed against white rather than dark wood, which seems to soak up the delicate shadows, deadening rather than enhancing the overall tone. Look for glass rather than heavy pottery, solids rather than patterns, especially florals, which can send it into the realms of daintiness. Keep it light and bright, and racy for a seasonally adjusted color.

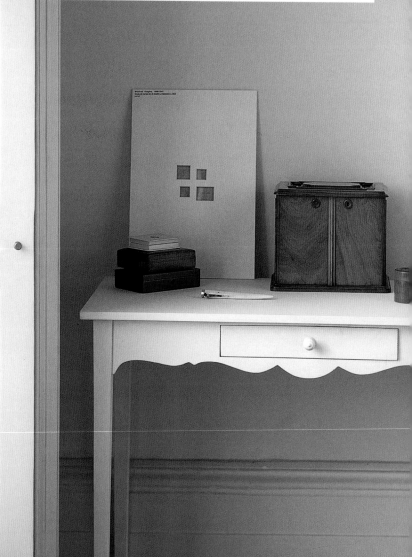

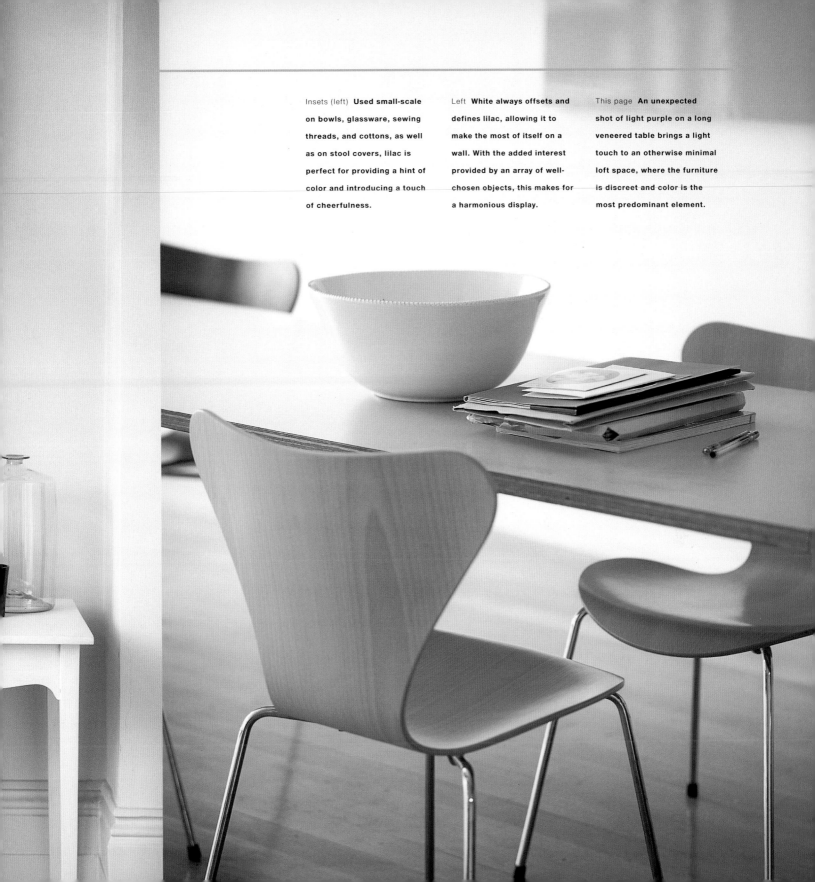

Insets (left) **Used small-scale on bowls, glassware, sewing threads, and cottons, as well as on stool covers, lilac is perfect for providing a hint of color and introducing a touch of cheerfulness.**

Left **White always offsets and defines lilac, allowing it to make the most of itself on a wall. With the added interest provided by an array of well-chosen objects, this makes for a harmonious display.**

This page **An unexpected shot of light purple on a long veneered table brings a light touch to an otherwise minimal loft space, where the furniture is discreet and color is the most predominant element.**

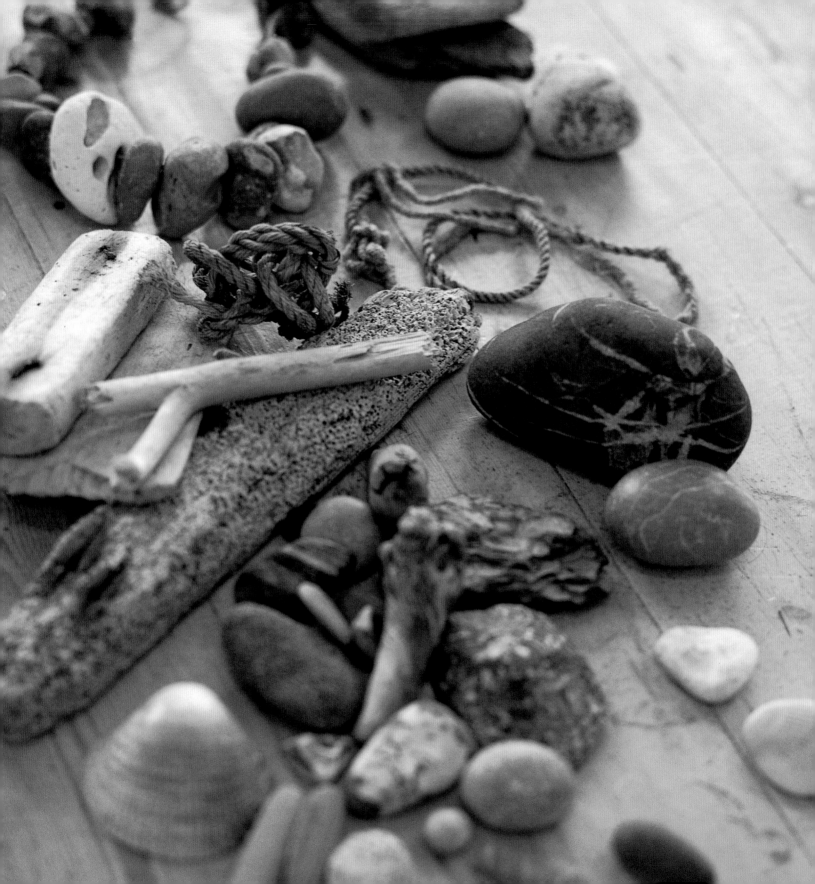

sea, sky, &driftwood

"Pure and
elemental, the
seascape colors
are part of our
essential being."

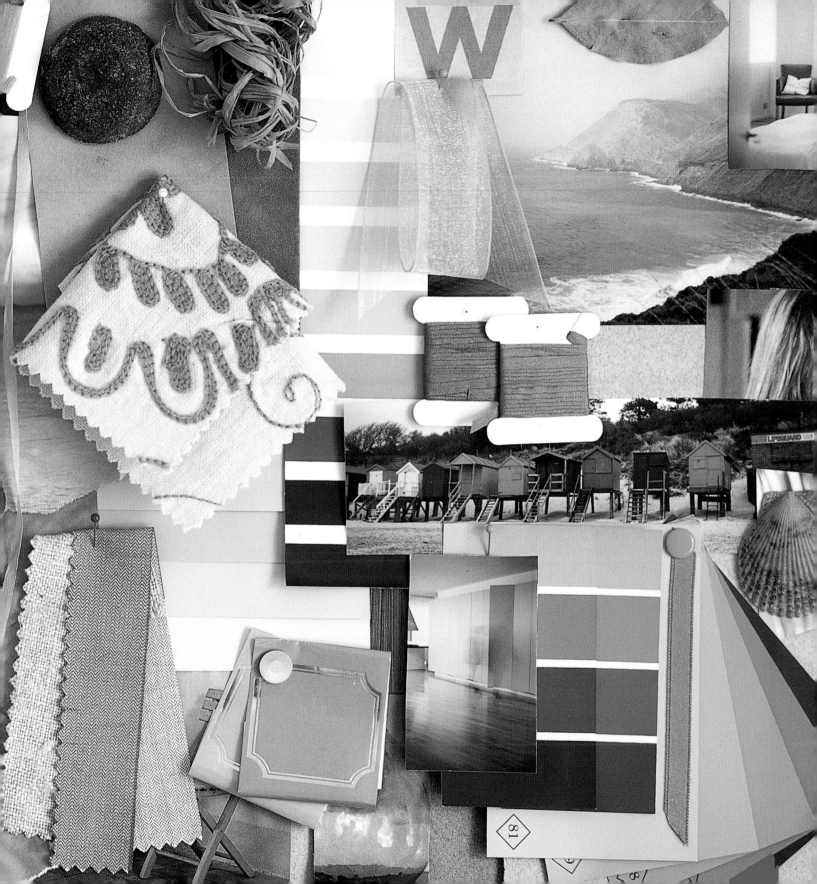

Imagine yourself standing on the seashore and examining the play of light on the colors and textures of sea, sand, and sky. Imagine watery sunshine filtering through pearly gray clouds; sudden patches of clear blue sky; pale silvery gray foam swirling over sand and pebbles and around your toes; the soft hazy tones of the shore; and how biscuit, beige, gray, and slate merge as sand becomes

from pale bleached ash to dark stained oak; and rough jute, hemp, and sisal that evoke boats and fishing nets and ropes. Aim to achieve a joyous symphony of quiet tones, muted colors, and to create a feeling of effortless relaxation.

Seascape colors bring to mind the pale grays of driftwood that has been worn to metallic silver by sand, sea, and sun as well as

"The textures and materials of sand, stone, sea, sky, and vegetation"

rock. When you think of the seashore, you see tufts of gray-green coastal grass, its spiky dryness blending with the dusty blue of sea holly and the grayish-mauves of candytuft and thrift, and the bonelike beauty of driftwood, sculptural yet raw in its stark angular lines. The colors of the sea can be subtle or strong, but are enchanting and easy to work with. They evoke a contemplative mood, soothing, relaxing and wistful, even a little sad. They are the colors of rain and tears.

Pure and elemental, the seascape colors are those that surround us naturally every day of our lives. Earth, stone, grass, sea, sky, and tree bark appear to be part of our essential being—so much so that we are always comfortable with them. These colors never fall out of fashion and always have a role in any decorative scheme, acting as a foil for more assertive shades, yet blending with them in a happy harmony of light and shade, strong and weak tones.

Despite their continuous popularity, seascape colors can still look as contemporary, vital, and uplifting as any others. Soulful colors soothe the nerves and are pure balm for the faded modern spirit. Easy to live with, always subtle and understated, these cool aquas, greens, grays, and blues are at their most pleasing when they are combined with rich, satisfying, natural textures such as soft linens and loose weaves; plain unpatterned fabrics; wood in any natural shade,

"Pure and elemental, the seascape colors are those that surround us naturally every day of our lives."

pebbles, whose inherent faded colors— olive, ocher, buff, slate, chalk, alabaster, and sudden surprises of purplish brown or brownish pink— are locked away until a salty splash of sea water reveals their jewelled tones. Imagine the deep, deep sea green of rock pools in the shade of cliffs or the glossy black and amber of seaweed trails floating in the gray-blue waves at the water's edge. Think of the sea on a stormy day— smoke-black skies, the sea a churning mass of Prussian blue and jet, surges of creamy foam tinged with sulfur as the dark waves slap over slate-gray rocks—and you have a palette of subtlety, depth, and emotion that is removed from the more obvious turquoises and cyan blues of postcards.

"Faded colors— olive, ocher, buff, slate, chalk."

From time to time, these cool gray-greens and blues have gained special favor. The Georgians in Britain used these elegantly restrained colors to great effect on their silks and damasks, and they looked very effective on the large expanses of painted paneling and handsome architectural features of the period. Robert Adam, the great 18th-century architect, is closely associated with these particular

"The palest tones of sky, egg shell, and celadon green are wonderfully elusive and have a delicacy that is unrivaled."

shades. Newly fashionable wallpapers often featured chinoiserie, toile de Jouy, birds, and plants. Georgian houses were usually paneled and painted in white lead-based paint tinted with earth colors or soft gray, pea green, or sky blue. These colors were combined with unobtrusive putty whites and cool sherbet yellows on walls and furnishings.

The Shakers were fond of a shade of blue called Heavenly Blue, favoring its use on all manner of surfaces and everyday objects, as an aid to contemplation and prayer and as a reminder of their spiritual purity. This deep, deep blue was used historically on the furniture and smaller details in a room to provide emphasis without domination. It is almost at the opposite end of the spectrum from pale duck's-egg blue,

"Watery sunshine filtering through pearly gray clouds."

and celadon green are wonderfully elusive and have a delicacy that is unrivaled. Often, people automatically equate blues and greens with strong, overstated Mediterranean colors chosen to stand up to the harsh sun, but these colors are equally successful, and much more restful, if selected from the paler end of the spectrum; they become a tribute to subtlety and restraint.

Decorating with the colors that are found by the sea can very easily degenerate into an exercise in the obvious, leading to a sharp but predictable navy and white or sky blue and white scheme that says no more than the strictly nautical. However, if you choose your seashore scheme carefully, it can become an uplifting mix, revealing the infinite subtleties that result from the textures and materials of sand, stone, sea, sky, and vegetation.

Exploit the sand-toned, textural approach still further by using seaside-inspired materials such as jute for curtains and floors, thick sisal matting on the floor, and rope or heavy string for tiebacks and drawpulls, and experiment

"The colors of rain and tears."

"Despite their continuous popularity, seascape colors still look as contemporary, vital, and uplifting as any."

which is endlessly versatile as a foil for silvery gray, dark chocolate brown, or silvery, neo-Rococo tones, proving that blue need not be cold, whether richly deep or subtly pale. Combined properly, it can be a warm color, tackled with tact, a timeless shade that ages well.

The deeper tones of indigo, Prussian blue, deepest aquamarine, and charcoal are useful for making a strong color statement without being overwhelming, while the palest tones of sky, eggshell, dove gray,

with burlap, the latest textural darling of interior decorators everywhere—for furnishings, or even stuck on the walls and the floors. Elsewhere, say on some or all of the walls and perhaps on the ceiling, use the quiet, sometimes wistful or almost sad, colors of gray-green, gray-blue, and simple pure dove gray to create an elusive color scheme that does not shout out a statement at you the moment you walk in a room but sets a well-measured tone of quiet contemplation.

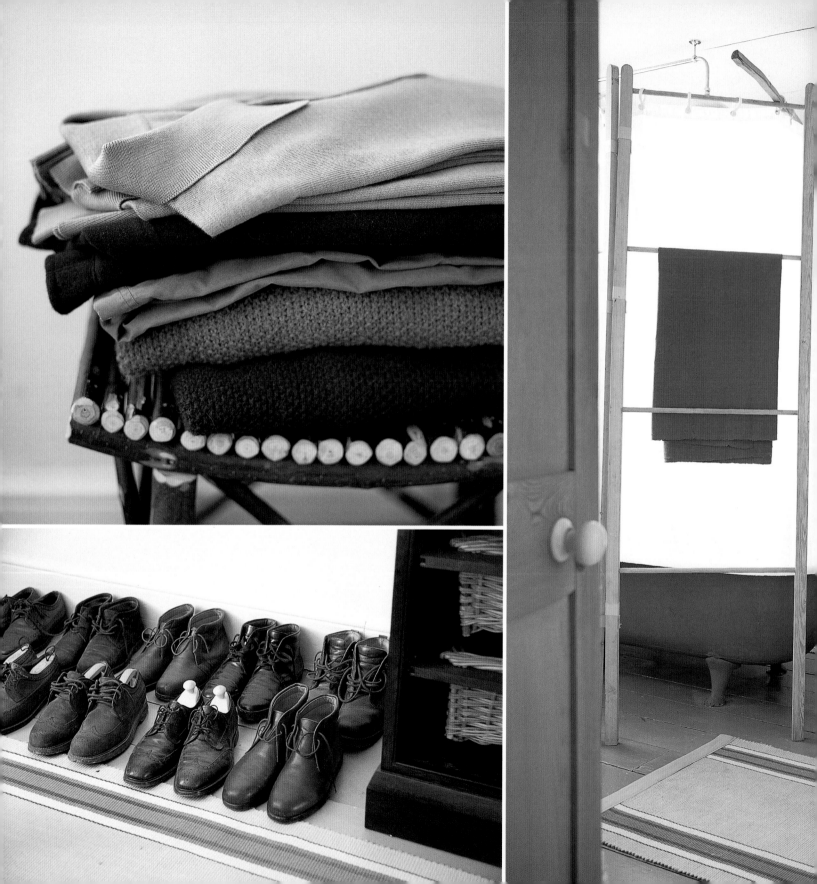

Far left (top) **In a room with such a watery theme, clothes just have to be of a sympathetic color and texture.**
Far left (bottom) **Shoes arranged in this way suggest organization and readiness for a walk on the beach.**

Left **Delightfully informal and delicately colored, this bathroom speaks of fresh, clean, coastal living. So effective is the scheme at creating the right atmosphere that you can almost feel the sea air doing you good!**

The seascape colors connect with one another in a fusion of blue skies, gray undertow, and sand-tinged coastal plants, suggesting honesty and gutsy tones.

the coastal path

Imagine yourself sitting on a sand dune, peeking through the grass and looking out to sea. There are forest-green pine trees behind you and miles of sand in front, mottled with water, shells, seaweed, and coastal flotsam and jetsam. Look at the colors. You have space and light before you, but more than anything else, you have blue, green, gray, stone, and bark, a pleasing coalescence of natural tones that both soothe and disturb, vying for your senses.

The colors in this section are among those that many people feel happiest working with. They are easy to relate to, accessible, and make intelligent combinations for informal color schemes. These rock-pool colors—cool, watery tones, seaweed green, gun-metal grey, indigo blue—don't rely on the sun for their intensity.

Bathrooms cry out for the influences of the coastal path, but don't let them become beacons of clichéd blue and white, all starfish and shells. This enormously inviting bathroom speaks of the sea in a quiet, controlled manner. Walls of soft pebble gray give elegance to the space, and a freestanding aquamarine bathtub is rigged with white canvas sails as a towel rod and shower-curtain support.

A simple turned bowl and a
Shaker box echo the clean
lines of the wooden furniture.

Center top **Filtering the light
with a delicate veil of putty-
colored linen throws shafts of**

sunlight onto a small
collection of cool, pale blue,
glazed ceramics.

Center bottom **A discreet
armoire is useful for storage
as well as decoration.**

Elsewhere, a linen press stained the color of pitch and the woven runners of soft, watery blues along the wide wooden floorboards manage to create a nautical feeling without resorting to the obvious. Old shopping baskets and a giant two-handled former log basket deal with the dirty laundry, but also invite you to dip your toes into their sand-colored depths. This is a wonderfully tranquil bathroom to start the day in.

Simple painted furniture, against wall colors that are neither strongly blue nor strongly green but gray-green or gray-blue, is marvelously relaxing and versatile for using as display areas for delicate white porcelain and ceramics that almost look touched by the sea as they show off their luster in the light.

Above **The soft rays of sunlight filtering through the blind into this sublimely decorated bathroom are highly evocative of the beautiful light found by the sea. The blind entices the idle onlooker to glimpse outside to see the view while also providing some privacy.**

Below **Displaying bowls against delicate multihued walls throws them into quiet but noticeable relief.**

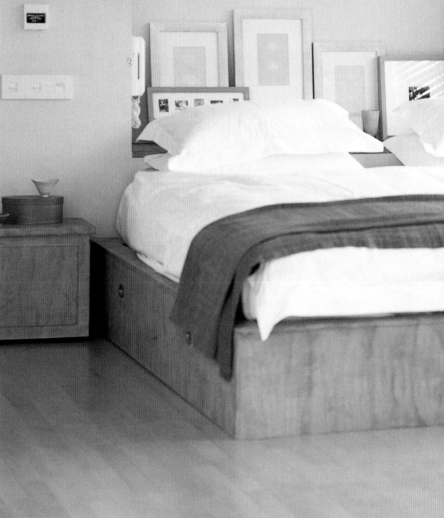

Top left **The frames for these
pictures are made of stained,
bleached, or distressed wood
and look like the layered and
battered patina of driftwood.**
Bottom left **Peeling paint, vivid
hydrangea, and sharp-toned**
ferns against a gray floor and
gray walls bring to mind a
relaxing beach cabin.
Below **A scumbled, sand-
toned bed base placed against
the palest aqua walls and
dressed with pure white**

sheets and a deep blue-green blanket conjures up images of a hazy day by the sea. Slatted blinds throw prongs of light, like sunbeams, onto the bed.

Top right Weather-blasted wooden and iron furniture speak of beach huts and a seaworn atmosphere.

Center and bottom right Blankets and ceramics with variations of texture and gloss stand out like jewels in the muted overall scheme.

beach retreat

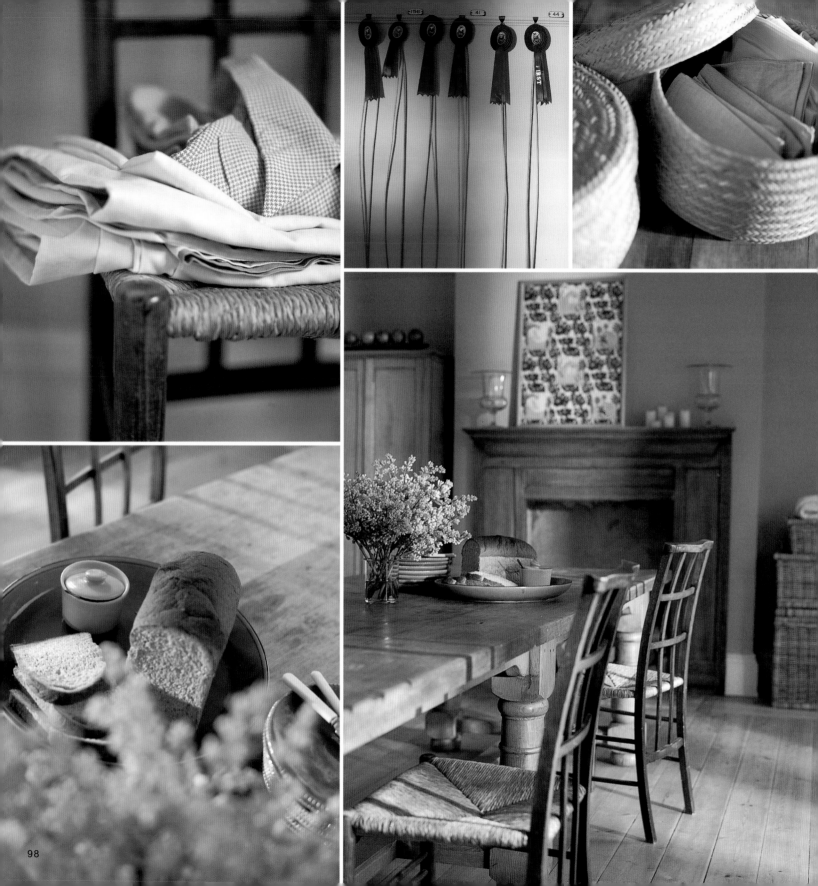

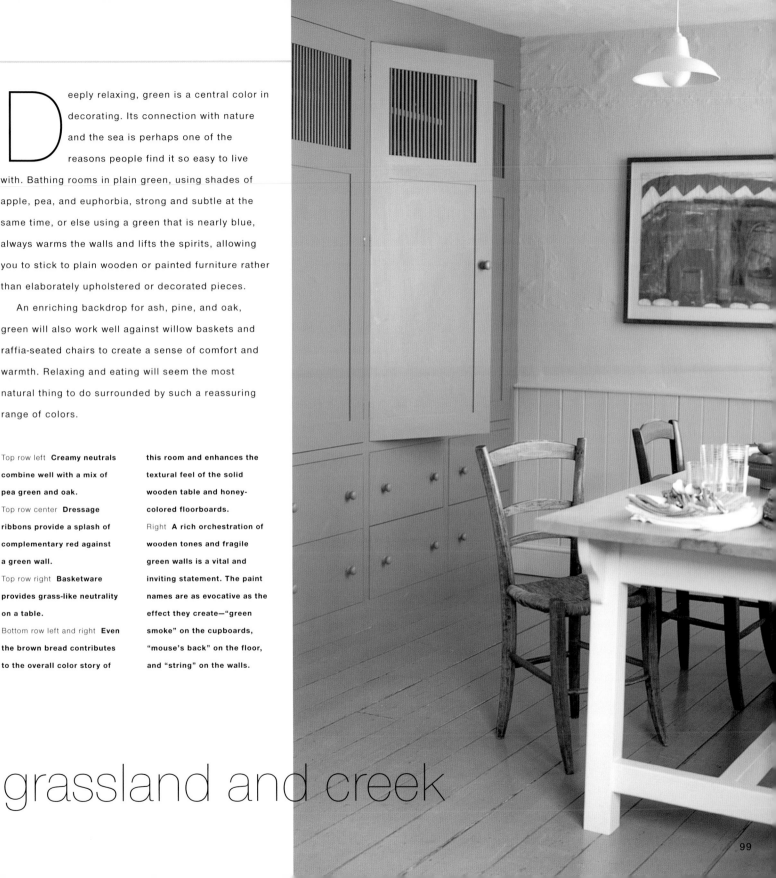

Deeply relaxing, green is a central color in decorating. Its connection with nature and the sea is perhaps one of the reasons people find it so easy to live with. Bathing rooms in plain green, using shades of apple, pea, and euphorbia, strong and subtle at the same time, or else using a green that is nearly blue, always warms the walls and lifts the spirits, allowing you to stick to plain wooden or painted furniture rather than elaborately upholstered or decorated pieces.

An enriching backdrop for ash, pine, and oak, green will also work well against willow baskets and raffia-seated chairs to create a sense of comfort and warmth. Relaxing and eating will seem the most natural thing to do surrounded by such a reassuring range of colors.

Top row left **Creamy neutrals combine well with a mix of pea green and oak.**

Top row center **Dressage ribbons provide a splash of complementary red against a green wall.**

Top row right **Basketware provides grass-like neutrality on a table.**

Bottom row left and right **Even the brown bread contributes to the overall color story of** this room and enhances the textural feel of the solid wooden table and honey-colored floorboards.

Right **A rich orchestration of wooden tones and fragile green walls is a vital and inviting statement. The paint names are as evocative as the effect they create—"green smoke" on the cupboards, "mouse's back" on the floor, and "string" on the walls.**

grassland and creek

summer skies

Top left, center, and right
Flatware with tortoiseshell handles; elegant ceramics that are pebblelike in both color and texture; and a heavy treetrunk-like table all recall the outdoors.
Below **A cushion covered with unusual brown-gray silk and decorated with light blue buttons preserves the peace in sky blue.**

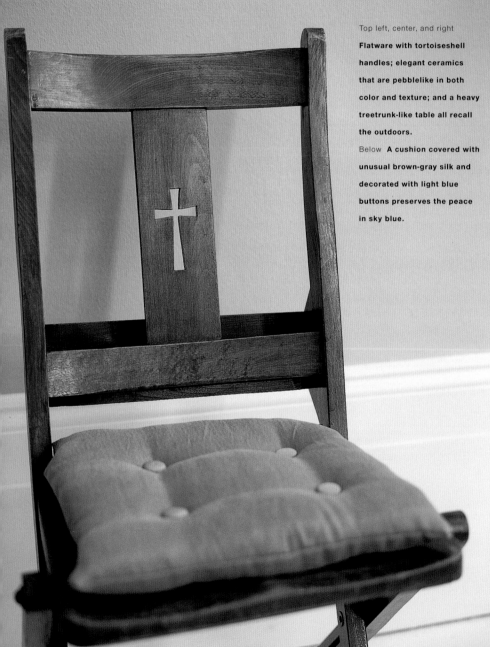

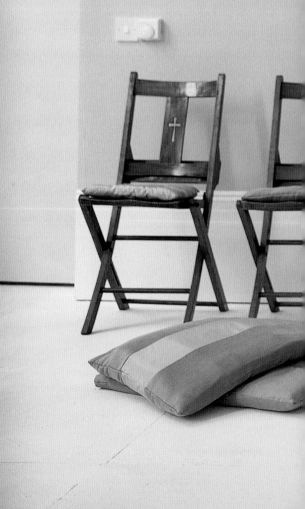

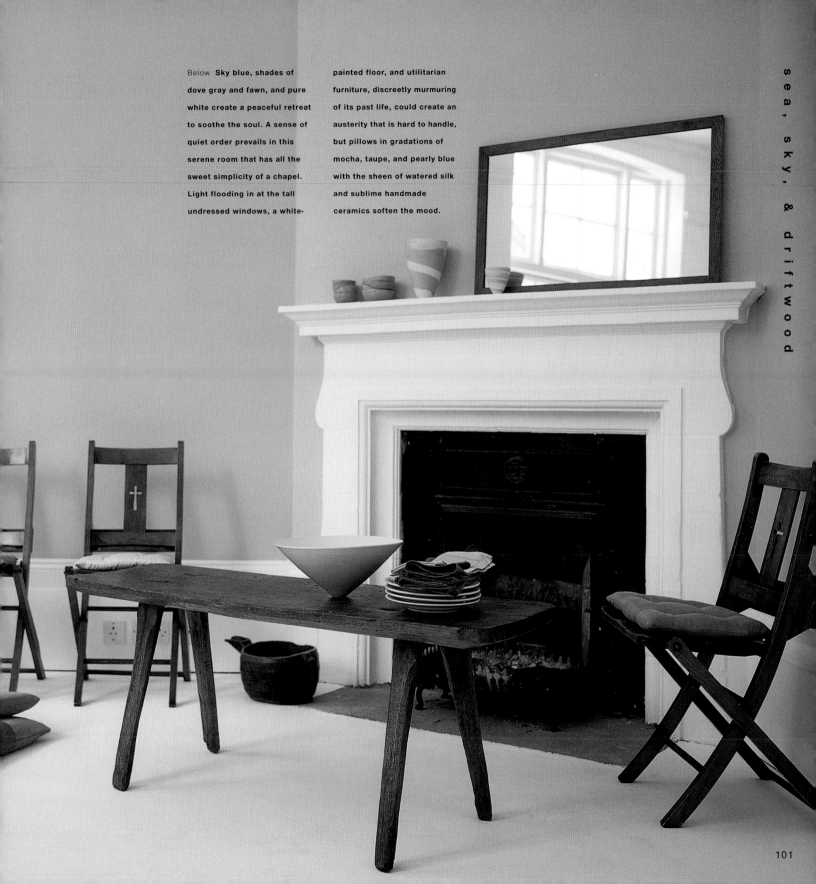

Below **Sky blue, shades of dove gray and fawn, and pure white create a peaceful retreat to soothe the soul. A sense of quiet order prevails in this serene room that has all the sweet simplicity of a chapel. Light flooding in at the tall undressed windows, a white-** painted floor, and utilitarian furniture, discreetly murmuring of its past life, could create an austerity that is hard to handle, but pillows in gradations of mocha, taupe, and pearly blue with the sheen of watered silk and sublime handmade ceramics soften the mood.

Well-chosen books from the family bookshelf or junk-shop finds such as glass bottles are just as decorative as a personal collection of finely glazed ceramic pots and lavender bags against lightly painted walls.

Center top Elephant-gray walls throw a dainty light into a room dominated by off-white walls and woodwork, a richly textured rug, and a dark wooden piano—all natural elemental colors.

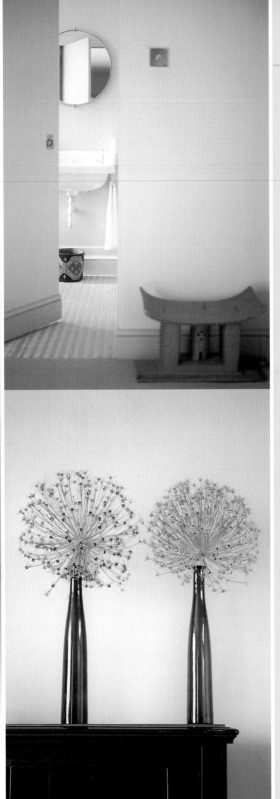

country walk

Clean, fresh, invigorating, and easy on the senses, pale shades of blue against white, brown, and quiet gray are gentle colors to work with in bedrooms, bathrooms, and living rooms. Their quiet subtlety quite simply enables you to relax. The trick is to mix dark with light, smooth with textured, while keeping your choice of furniture and accessories as simple as possible. Uncluttered, functional but still clearly beautiful is what you should aim for when re-creating the color themes that you see on a country walk. The easiest way to achieve this is by looking at a collection of birds' eggs, dried allium heads, or ceramic glazing to set you on your way.

Center bottom **A silk bedspread with a central stripe of blue-gray ties a bedroom scheme together.**
Above left **Bathrooms always work as clean white spaces.**

Below left **Tall brown glass bottles make elegant vases for allium heads on top of a piano.**
Inset **Waferlike edging on a ceramic bowl echoes the speckled surface of eggs.**

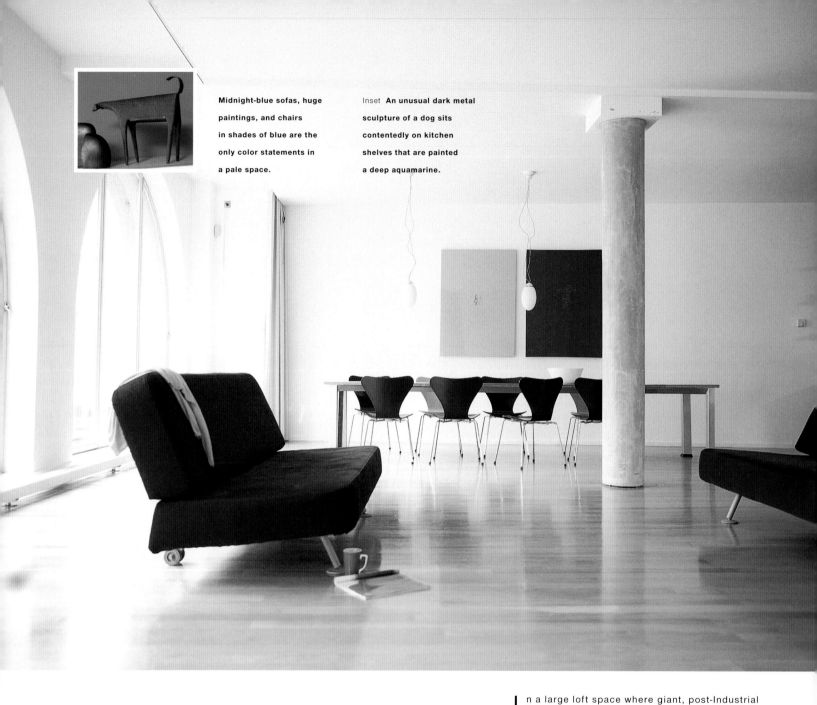

Midnight-blue sofas, huge paintings, and chairs in shades of blue are the only color statements in a pale space.

Inset An unusual dark metal sculpture of a dog sits contentedly on kitchen shelves that are painted a deep aquamarine.

seaside special

n a large loft space where giant, post-Industrial windows shed light in all directions, color makes a statement on the furniture, built-in cupboards, and wall canvases as splashes of hue and tone in an otherwise neutral space. Color is as much architectural as decorative in a place that couldn't be

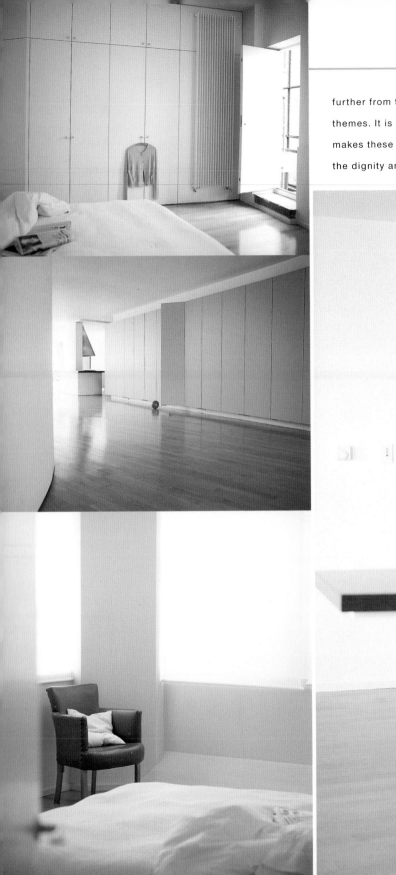

further from the sea, yet employs water-inspired color themes. It is the very neutrality of the background that makes these pieces of furniture stand out, giving them the dignity and presence of large sculptures.

Floor-to-ceiling cupboards and paneling are sprayed a pale eau-de-nil in this bedroom and spacious hallway.

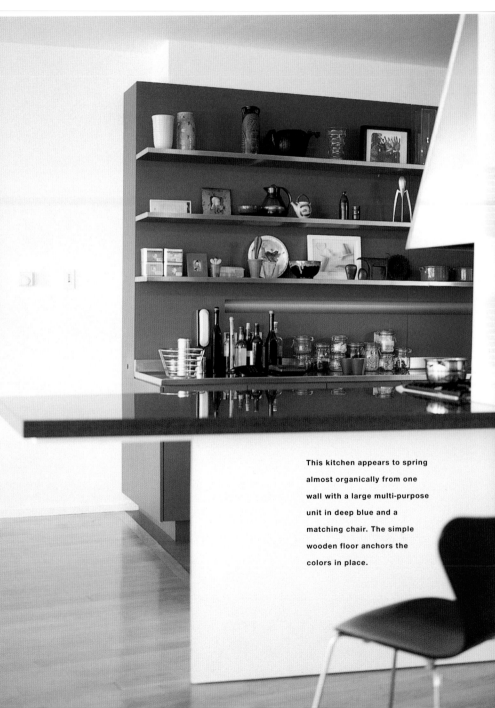

This kitchen appears to spring almost organically from one wall with a large multi-purpose unit in deep blue and a matching chair. The simple wooden floor anchors the colors in place.

red wine & roses

Red speaks volumes. It is primary, positive, and affecting, the visual equivalent of Tchaikovsky's *1812 Overture*—grand, important, noisy, and noticeable. Red is active rather than passive, stimulating rather than relaxing. The color of flame and passion, red is a statement color; together with violets and blues, it is more popular in color preference tests than oranges, yellows, and greens. In fact, it is the color most women favor above all others, whereas men often choose blue as their signature color.

Even the names we use to describe reds, such as scarlet, vermilion, cardinal, magenta, carmine, crimson lake, Venetian red, rose madder, ruby, garnet, lacquer red, and claret, are powerful and evocative, sensual and symbolic. Red is the color of energy, spirit, power, vigor, love, sexuality, passion, and danger. It suggests both love and hate. While its associations extend to romantic red roses and scarlet boudoirs, it has always been connected with evil, too, being the color of the devil and of fire. Greek and Roman mythology depicted red on the torch of Ceres, the goddess of agriculture, while Bacchus, the god of wine, was often portrayed with a red face. In China, red, not white, is the color of marriage, and for Native American Indians, red stands for the desert and for disaster. Think of the rich red walls of Pompeii, Regency stripes, and the potent barn-red on the traditional buildings of the American countryside, whose color comes from the red oxide-based paint made from the indigenous earth of the area. American Federal red is another natural color, mixed from iron oxide that comes from the earth in rich quantities. Early North American interiors are instantly evoked by simple painted woodwork and furniture, cottons and calicos in homespun weaves, checks, ticking, and sprigged prints, almost invariably using these gentle soulful tones and nuances. The natural world contains many different shades of red. Just think of scarlet poppies, vibrant

"Wherever it is, red makes its presence felt."

clusters of raspberries and strawberries and burgundy grapes as well as the passing flashes on birds such as woodpeckers, parakeets, and robins. Sunsets, too, are composed of literally hundreds of different red, orange, and violet hues.

You cannot help but react to rooms decorated with vibrant red. The mere presence of the color is capable of physically accelerating our metabolic rate. It has such an acknowledged effect on blood pressure, increasing the flow of adrenaline and the pulse rate, that many restaurants, fast-food chains, and dining rooms have long been painted in shades of deep scarlet to enhance the eating experience and take conversation to new heights of erudition. Anyone living with such a vivid color, however, physically adjusts to their surroundings over a period of time, so that the body ceases to react so strongly to frequent jolts of the color.

"You cannot help but react to rooms decorated with vibrant red."

Red is not for the faint-hearted, but any color that is so much a part of all the driving forces of our lives should not be excluded completely. People who choose to live with red are often ambitious, with a strong zest for life and a need for excitement. Brave and bold, red will bathe a room with constant warmth, even one that does not receive much natural light. At night, the space becomes cozy with reflected light. Red is wonderful partnered with any neutral color, from pale beiges and grays through to chocolate browns and black. Red can be very exciting when used tonally with colors that are near it in the spectrum, where vermilion fades into cinnabar, chestnut, and tortoise-shell or crimson melts into damson, deep vine, and purple. It also sits well against navy blue, green-blues, and gray-blues.

Wherever it is, red makes its presence felt. Although eating areas are the obvious place for it, halls also like a splash of red to create an active sense of welcome. North-facing rooms are positively warmed by such a rich color, but the bedroom is probably not the most ambient

"Red for drama, purple for passion, roses for emotion."

Historically, red has enjoyed huge popularity, from the Tudor period, when wall hangings were in vogue to Empire salons, Colonial American farm buildings, and Georgian living rooms. By all means, emulate these historical interiors, but try to choose contemporary furniture and fixtures to counter the strong period references. This approach does take some skill, but get the mix right and you will have a stunningly effective color scheme that says much about your strength of character.

space for such stimulating tones, especially when the body craves rest and relaxation. However, it is interesting to note that very young children can only perceive the three primary colors, so red would provide a stimulating environment for a small person. You can also use red in kitchens, living rooms, and dining rooms to create a womblike welcome that embraces visitors and puts them at ease.

If red seems too strong a color with which to furnish your home, use it on a small scale, as an accent on architectural details such as cornices, moldings, or baseboards and on furniture. It works well in such small doses. The more timid might also like to drench the front door with a couple of coats of rouge red to make a bold welcoming statement or wash one wall with a coat of rich scarlet and let the others languish in its warm reflections. You could also paint doors and woodwork in a strong deep tone or incorporate large window treatments, bold pieces of furniture, or painted furniture in rich and vivid shades of crimson, vermilion, or scarlet.

Over the centuries, red has been used to symbolize power, wealth, and luxury. Indeed, it is at its most seductive on rich fabrics and materials, such as scarlet silk, crimson velvet, deep red leather, claret brocade, or burgundy damask. These combinations are undeniably gorgeous, but unless you wish to evoke a Victorian brothel or a sultan's palace, it is perhaps best to temper these materials with plain, simple elements.

Red can be used to create a host of different moods, including the utterly luxurious. Just think of how sofas with red upholstery provide instant warmth in a room with neutral walls and floors as well as the freshness and innocent appeal of classic red-and-white gingham and the Eastern extravagance of sheer red voile.

Purple is another color that evokes strong reactions. While some adore the rich velvety tones and regal associations of deep purple, others find it insipid, neither blue nor red enough, but something indiscriminate between the two. Purple can be a strong color, however, imbued as it is with hints of extravagance and luxury. Violet and purple are rarely found in nature, so are all the more distinctive for being less in everyday existence. Strong purple is a definite shade that works well on smaller surfaces in a room—as a bed throw, on curtain fabric, or on a rug or painting, for instance. It is overwhelmingly chic when used for impact against white or cream.

Both red and purple make sense used over one or two surfaces in a room. If you use them with a sense of scale in mind, they won't overwhelm the space. Most people unconsciously try to devise color schemes that strike a balance between calming and stimulating colors, so counteracting strong color by using diluted tones of each is a good way to embrace red and purple without them engulfing you.

> "Use red as an accent on architectural details for an instant kick."

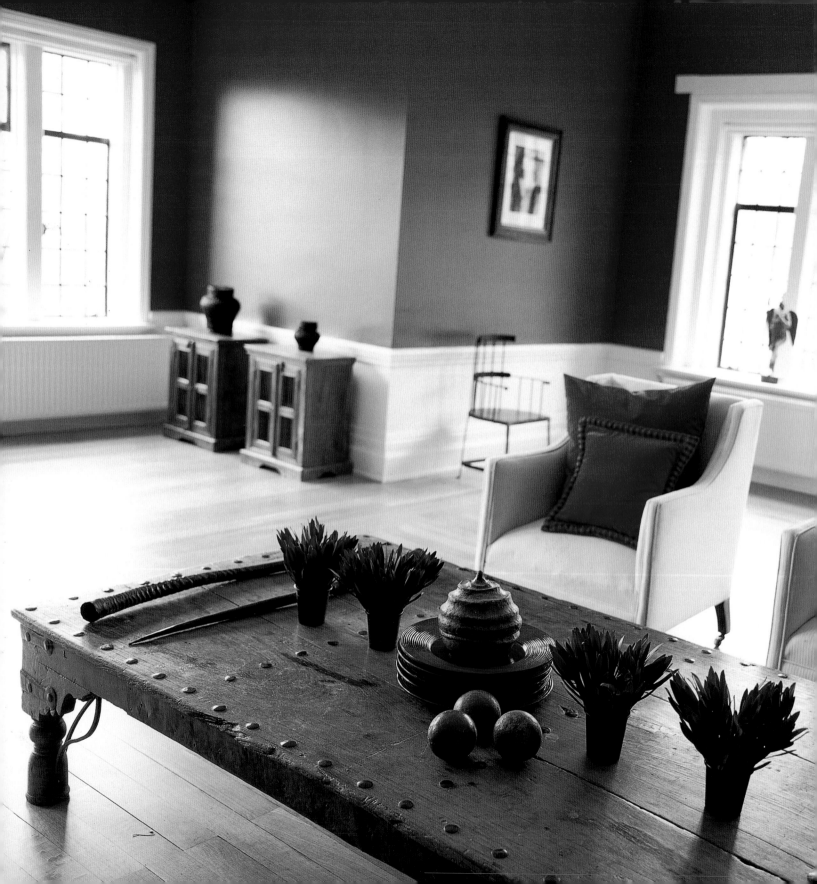

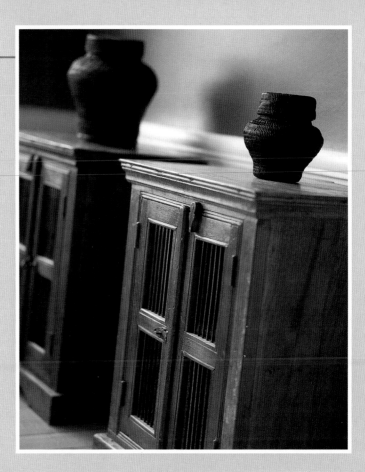

Left **Use color to create a specific ethnic look and combine it with a few apposite artifacts for a complete treatment. In this harmonious living room the large scarlet pillows on the chairs echo the warm red of the walls. Even the rich brown of the solid table enhances the feeling of warmth and well-being.**

Right **A pair of heavy Indian teak cupboards line up for storage duty, topped with equally heavy but sensuous charcoal-black baskets.**

east meets west

Rich red is opulent and substantial, imposing and seductive. Use it with confidence on a grand scale or as obvious highlight for glamour and gloss.

Deep wine-red walls provide an enclosing warmth that simply cannot be ignored in a large living space. The place demands to be taken seriously, defined well, and respectfully complemented. One of the reasons this room works so well visually is because it is defined and highlighted with white and wood. Walls are painted white below dado height and

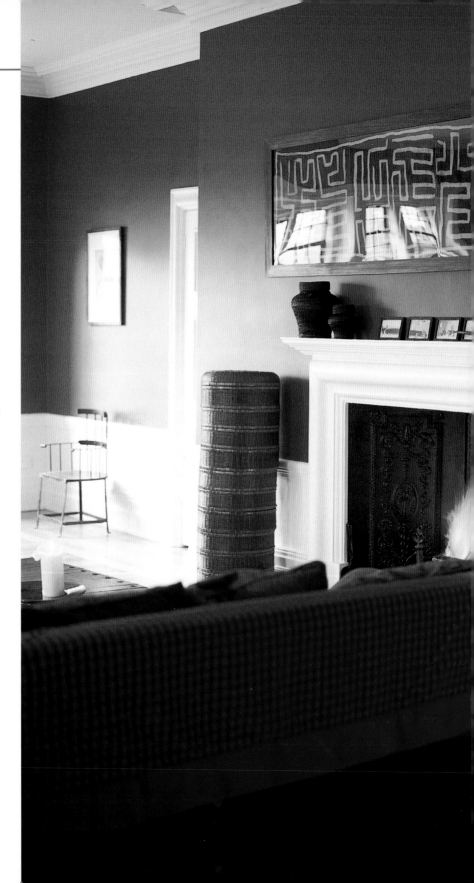

Right **Making a feature of a piece of embroidered ethnic fabric is the perfect solution for a room with such a strongly exotic atmosphere. It is decoration enough above the pale substantial mantelpiece. A large multiwick candle, which resembles a large squat cheese, provides additional flickering light that dances warmly around the smart pristine fireplace.**

Far right top **Pillows are the perfect accessory for completing a color story, whether they are extending the color theme or creating a dramatic contrast with the prevailing picture. Here, the pillows harmonize with the wine-red walls.**

Far right bottom left **The studwork on this low coffee table gives a pleasing and interesting texture to an otherwise smooth, streamlined room. The dainty wooden vases filled with small sprigs of red flowers give the room further textural emphasis as well as toning discreetly with the other red elements in the room.**

Far right bottom right **These unusually shaped papier-mâché boxes look like exotic fruits of unknown provenance. By choosing unusual artifacts such as these as decoration, the room takes on the air of an exotic bazaar, and the sense of adventure is maintained down to the last detail.**

the window frames become extensions of this definition. A plain wooden floor makes for light relief, while white upholstery prevents the space from darkening too much.

A Rajasthani coffee table, African woven baskets, and ethnic cupboards distance the space from the English countryside and allow it to hover somewhere between northern Africa and the rain forests. This is a tribute to global style in an English period setting, complete with a glowing fire for extra flaming tones. Using red on walls is often all that is needed to create a whole color scheme. You can add furniture and furnishings in the same color, but beware of slipping into overkill. It is better to use wood, preferably stained dark, for a defining edge.

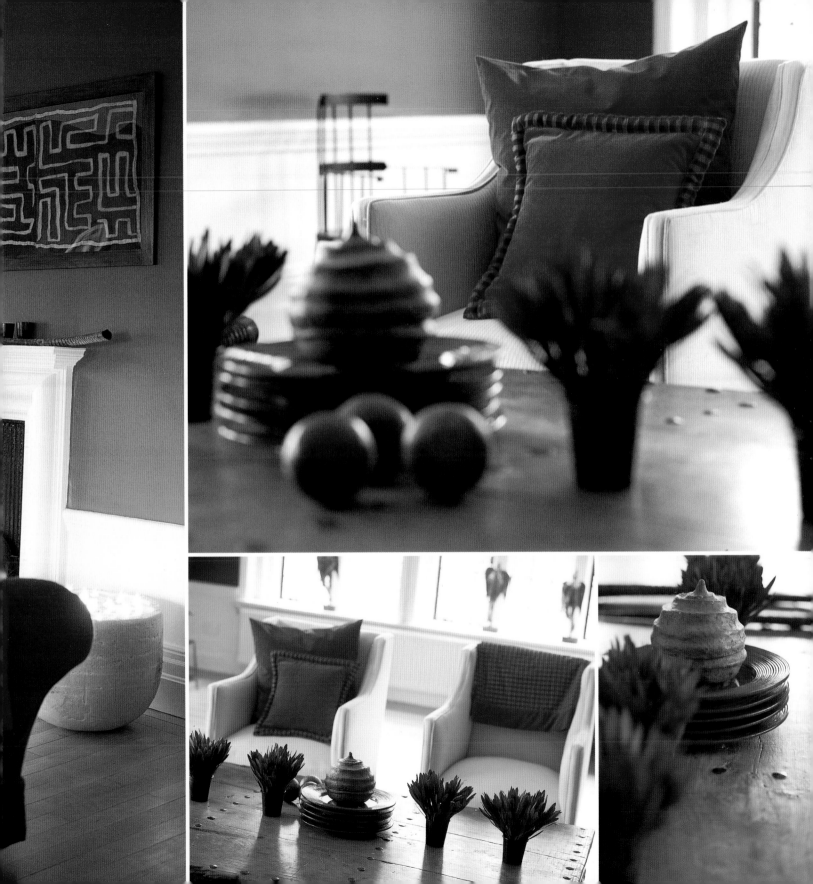

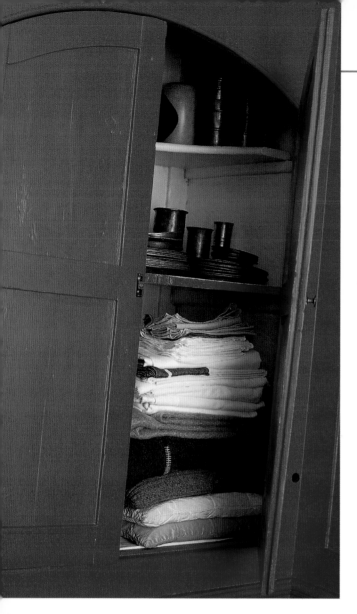

The Georgians loved red, but a different red from this glorious poppy-toned statement in a 250-year-old house. A sharp intake of breath is the initial reaction when faced with such an expanse of dramatic color, but in fact, the senses adjust quite quickly and soon the naturally enclosing paneled walls envelope you with a lush feeling of warmth and security.

Nothing is quite as it seems in such an old house. It is common to find, as here, that the walls do not always quite meet the floors in the expected manner. The cupboards also creak with the slightest movement, while the fireplace whistles mysteriously as the wind eddies down the chimney. However, the overall feeling is a vibrant one, despite the Dickensian overtones.

In the living room, poppy red is toned down and made more serious with the addition of white, charcoal gray, and of course, black, a positive definer, in a variety of scale and materials. Red and gray are always a stylish combination, since the gray stops the red from being loud and outrageous. Pewter, with its matte but reflective surface, can really be appreciated against the strong color, while black-framed prints stand out from vivid walls.

defining glory

Above **A cupboard that has been recessed into the wall hides the linen in a color-coordinated manner so the doors can be left open.**

Top right **Black and gray ceramics mixed with Indian weights on a ledge are elegant.**
Center right **Trying out different reds and grays prior** to painting the room yielded a modern painting.
Bottom right **Pewter provides just the right tone of gray for decorative plates and cups.**

Far right **The irregular lines of floorboards, wall paneling, and mantel shelf work in harmony with the strong red to create a pleasing patchwork of color.**

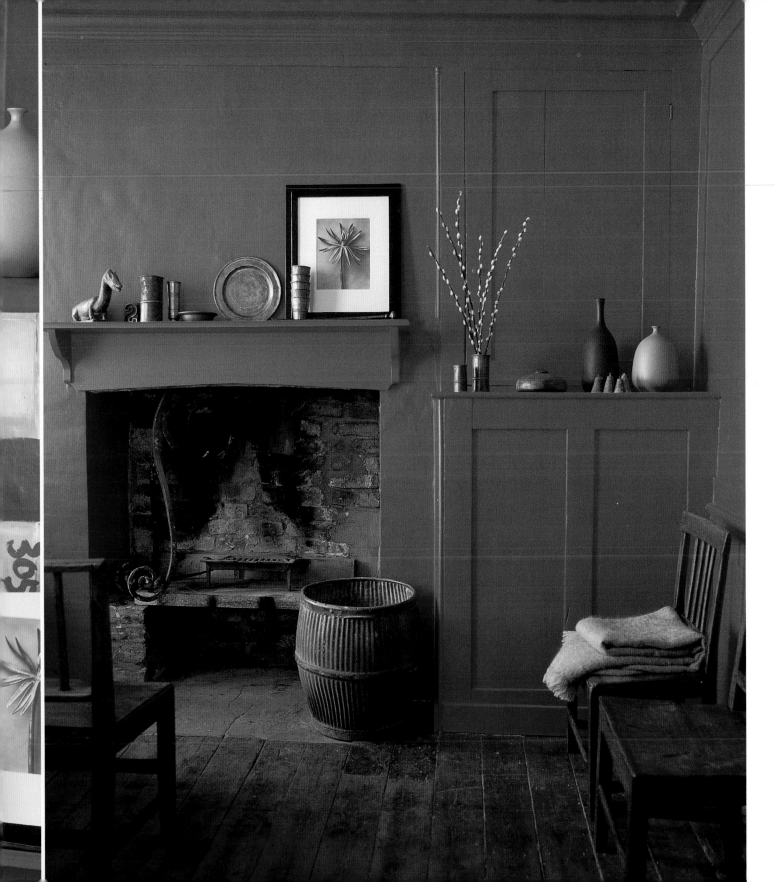

purple for passion

Purple is a strong color and, like red, it can frighten people if it is used on a large scale. However, the deeply inviting splash of purple of this luxuriant throw speaks only of love, not of loathing.

Center top Calla lilies that are almost black in their intensity, rather than purple, make a handsome and sumptuous bedside statement.

Center bottom The subtle selection of purples and pinks to be found inside a garlic bulb can provide the inspiration for a clever decorative scheme.

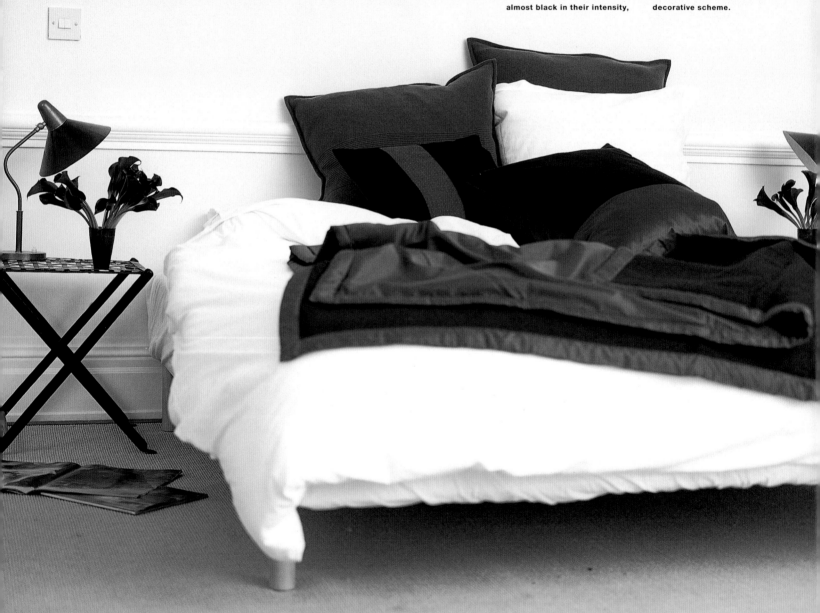

Far right top **Purple is often associated with brooding teenage bedrooms. But it can throw off this reputation if used in muted shades.**

Far right bottom **Purples that are mixed together on a small scale can make rich, vivid statements.**

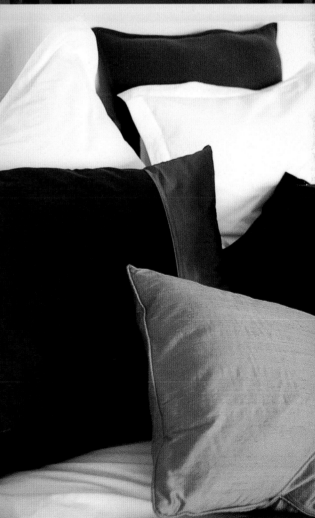

Left **Accessories such as baskets for holding paperwork, magazines, or general clutter can be used to make decorative statements; they are also useful seminatural objects for defining a color scheme.**
Center, top left **Twig chairs with woven raffia seats are given sharp definition with red wool pillows in a happy mix of materials.**

scarlet definition

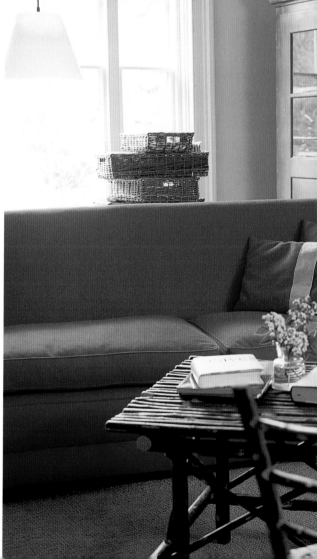

Painting your walls with a strong color such as red may seem overly dramatic, but consider the possibilities of using red for sharp relief, as a natural definer, or for making one-off color points. In this living room, decorated in modern country style, right down to its twig chairs and baskets, scarlet red creates strong patches of color that make the room vibrate with vitality. The clever use of natural textures with red makes this space relaxing as well as vivid. The rough edges of raffia, matting, and basketry soften the sharp outlines of a scarlet sofa and poppy pillows, making them less jarring. Red always makes an impact, on whatever scale, but here it has a quiet confidence that is quite out of character. Yet for a home on the Welsh border, red is ideal given its connotations with Welsh red flannel and the national costume. Here, geography and culture are good starting points for a scheme.

Center, top right **A giant, winged, biscuit-colored linen armchair needs nothing more in the way of decoration than a large scarlet pillow and a loving visitor to disappear into its welcoming folds.**
Center, bottom **In a room that is defined by red, a brown glazed armoire is used to house a striking collection of ceramics in reds, greens, and blues. Designed by Janice Tchalenko, they are displayed to good effect on green shelves inside the armoire.**
Far right **A country home is not complete without a delicate sprig of flowers picked from the garden to finish off the space and to bring scent to the room.**

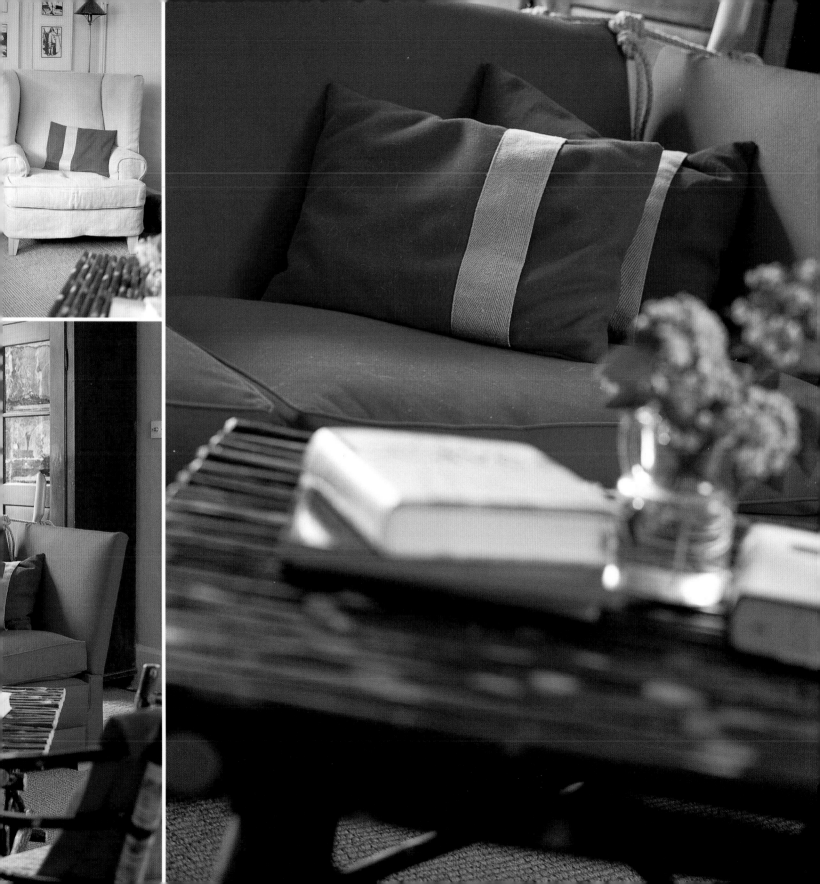

palettes and paint

pages 38–39 calm, white, neutral

pages 42–43 bleached beauty

The color swatches shown here represent some of the palettes that were used in each of the color stories in this book. Many of the schemes demonstrate only subtle color differences that balance together in a quiet harmony. These schemes evoke tone, shade, and nuance and prove that, while strictly regimented matching schemes are a thing of the past, colors that really work together produce a harmony that is undeniable. Each color palette illustrated here is accompanied by page numbers to indicate where you will find images of the decorative schemes and locations that use the colors.

pages 44–45 natural linen

pages 52–53 wild about wood

selecting colors

Playing around with shades and colors before you commit them to walls, fabric, and furniture is as much a part of decorating as opening a can of paint. Choosing the right colors should be a positive process, one that is well worth taking time over if you want to avoid the usual disheartening chore of painting a whole wall only to discover the resulting color is wildly different from the perfect picture you are carrying in your head. Getting this preliminary

pages 50–51 classic glamour

pages 62–63 hot chocolate

pages 60–63 hot chocolate

pqages 60–63 hot chocolate

pages 64–65 terra cotta, honey, and steel

pages 66–67 mocha moods

pages 68–69 stone and steel

pages 70–71 cinnamon and cloves

pages 78–79 pretty in pink

pages 80–81 soft mimosa

pages 82–83 purple haze

process right will save you much repainting at a later date and allows you to experiment with color combinations that you might not normally consider.

When deciding on the right combination of shades for a particular room, take time to look at the space, what will go in it, and how best to enhance both the room and its contents with color. Think about your favorite colors and decide whether any of them work in the context of decorating. You should also think about who will use the room. There is usually more than one set of likes and dislikes to accommodate, and comparing ideas may throw up a new combination. Often you will have an obvious starting point, such as a new sofa or favorite pair of curtains. In a new home, don't be panicked into choosing a sofa in one color, a dresser in another, then find yourself with a color scheme that has imposed itself on you rather than the other way around.

Tear out pages from magazines and remember to use your visual diary to build up a picture of a color scheme you really like. Once you have picked out the colors that fit your needs, start thinking about paint. Buy sample cans of paint so you can play around with scale. Use a small cardboard box as a mock room and paint all the surfaces as you would in reality, to gauge how certain colors reflect or absorb light.

paint finishes

Paint is to decorating what fresh ingredients are to a cook—vital, transforming, and satisfying. It is available in an extensive choice of colors, finishes, and textures, so experiment with types of paint as well as colors when you are planning a new scheme. Small areas of gloss work will throw specific architectural features

pages 92–93 the coastal path **pages 96–97 beach retreat**

page 98 grassland and creek **pages 100–101 summer skies**

pages 94–95 the coastal path **pages 104–105 seaside special**

pages 120–121 east meets west **pages 116–117 defining glory** **pages 118–119 purple for passion**

into sharp relief, while matte, chalky, water-based paints will lend textural interest to furniture and doors. In a plain, monochromatic scheme, detailing picked out in a different type of paint always adds definition with style.

Technology is constantly offering new forms of paint with an ever increasing choice of names and properties, which means that there is no excuse for not attempting to transform your home with paint. Any tired box of a room can come alive with sympathetic color on walls and other large surfaces. The array of paint types on offer can be confusing, but bear in mind that they are either water- or oil-based, which means that they are suitable for different surfaces. The main types of paint used in decorating are described below.

Water-based paint is commonly referred to as latex. It is easy to apply, quick-drying, and kind to the environment. Water-based paints are wipeable but not usually washable, so are not as tough as some oil-based paints. Flat latex has a matte finish, is inexpensive, and quick to apply and re-apply. For this reason, it is just the right choice for walls. It is a versatile medium which can be diluted with water to create a colorwash and also works well as a base coat for other decorative paint finishes. For a mid-sheen finish, vinyl silk or satin latex can be used on walls. This paint does not cover as easily as flat latex but is tougher and easier to wash.

Oil-based paint is tough, durable, irresistibly shiny, and is usually applied to woodwork, furniture, and floors rather than walls; it can also be used on metal. High-gloss paint is slow to dry and quick to chip, providing an uncompromising finish on woodwork and highlighting imperfections. For this reason, it should only be used on clean, smooth surfaces where a glossy sheen is just the ticket. Eggshell is the oil-based equivalent of vinyl satin and offers a mid-range sheen for woodwork. Once used only by professional decorators, eggshell is now popular domestically and often sold under the name of satinwood or semigloss. It is easy to apply, washable, and can also be used on walls more readily than high gloss.

varnish

A coat of varnish is ideal for protecting water-based paint finishes as well as providing a flat or shiny sheen, depending on whether you use dead-flat varnish or not. Water-based varnishes are less harsh than the noxious oil-based varieties, which are strong pollutants. Oil-based varnishes are extremely durable, particularly yacht varnish, but they have a distinct yellow or brown tint that will the affect the color of the paint, turning a color such as pale blue into pale green. Always test the combination of paint colors and different varnishes on piece of card before you begin painting.

source directory

The publisher and authors of *Color* are not responsible for the products sold by the following companies, and it is not our intention to promote any of these purveyors.

paint for walls and furniture

Benjamin Moore Paints

Montvale

New Jersey

New York, NY

Good period-style colors in muted shades.

Charrette Favor Ruhl

31 Olympia Avenue

Woburn, MA 01888

Painting materials and paints for interiors and exteriors.

Fine Paints of Europe

800-332-1556

Distributors of several lines of fine paints, including Martha Stewart's "Aracuna" paints, . The color selection is derived from natural sources such as stones, shells, leaves, and petals.

Home Depot

449 Roberts Court Road

Kennisaw, GA 30144

Paint, equipment, and materials.

Janovic

30–35 Thompson Avenue

Long Island City, NY 11101

Good color range.

Old Village Paints Ltd

P.O. Box 1030

Port Washington, PA 19034

800-498-7687

Authentic color reproductions from the Colonial, Federal, and Victorian periods.

Pearl Paint Supply Company, Inc.

308 Canal Street

New York, NY 10013-2572

800-221-6845

Wide variety of papers and boards, plus fabric paints.

Pittsburgh Paints

PPG Industries, Inc.

1 PPG Place

Pittsburgh, PA 15272

Good color range.

Sherwin Williams

101 Prospect Avenue

Cleveland, OH 44115

Good selection of colors for any style of interior.

Daniel Smith

4150 First Avenue South

P.O. Box 84268

Seattle, WA 98124-5568

800-426-6740

Wide variety of decorating supplies.

Ralph Lauren Paints

800-379-POLO (800-379-7656)

A vast collection of wonderful colors that evoke the rugged and sun-drenched outdoors, divided into themes such as Suede, River Rock, and Desert.

Colonial Williamsburg

Department 023

P.O. Box 3532

Williamsburg, VA 23187-3532

Selection of vintage paints.

fabrics

B & J Fabrics

263 West 40th Street

New York, NY 10018

212-354-8150

Natural fiber fabrics including velvets.

Calvin Klein Home

Flagship store:

654 Madison Avenue

New York, NY 10022

212-292-9000

Out of New York call 800-294-7978 for a store in your area. Pure and simple linens of the finest quality and the cleanest lines.

Designers Guild

at Osborne & Little

979 Third Avenue

New York, NY 10022

Bright contemporary fabrics and checked bed linen.

Laura Ashley, Inc.

6 St. James Avenue

Boston, MA 02116

800-367-2000

English-garden-look floral stripe, check, and solid cotton fabrics in a terrific range of colors.

Ian Mankin Fabrics

Available through Coconut Company

129-31 Greene Street

New York, NY 10012

212-539-1840

A complete line of cotton fabrics in solids, stripes, and checks.

Marvic Textiles

979 Third Avenue

New York, NY 10022

A good range of upholstery textures in smart colorings

Ralph Lauren Home Collection

1185 Sixth Avenue

New York, NY 10036

For a store in your area, call 800-377-POLO (800-377-7656)

Stylish accessories, including tableware and wonderful cotton and linen fabrics by the yard.

furniture

Nest

2300 Fillmore Street

San Francisco, CA 94115

415-292-6199

Vintage painted furniture and textiles.

Palecek

P.O. Box 225, Station A

Richmond, CA 94808

Manufacturers of painted wicker furniture.

Ruby Beets

Poxabogue Road and Route 27

P.O. Box 596

Wainscott, NY 11932

516-537-2802

Painted furniture, old white china, and kitchenware.

Wolfman Gold & Good, Inc.

117 Mercer Street

New York, NY 10012

212-431-1888

Furniture, accessories, flatware— some old, some new, all delightful.

floorcoverings

ABC Carpet & Home

888 Broadway

New York, NY 10003

212-473-3000

Contemporary and Oriental rugs and carpets; natural fiber floor coverings; small-space area rugs.

Armstrong

P.O. Box 3001

Lancaster, PA 17604

800-233-3823

Makers of sheet vinyl and vinyl tile in a wide variety of colors, finishes, and styles.

Bruce Hardwood Floors

P.O. Box 660100

Dallas, TX 75248

Strip, plank, parquet, woodtile, and acrylic-impregnated hardwood floors.

Congoleum

P.O. Box 3127

3705 Quakerbridge Road

Mercerville, NJ 08619

800-934-3567

This service-oriented company manufactures a complete line of sheet vinyls, vinyl tiles, and wood laminates in an extraordinary variety of colors and patterns.

Gerbet, Ltd

P.O. Box 4944

Lancaster, PA 17604

888-359-5466

German-made linoleum sheets and tiles.

Janovic Plaza

718-786-4444

New York City- and Nassau County, NY-based retail stores carry a variety of vinyl tiles and flooring materials.

Mary Moross Studios

122 Chambers Street

New York, NY 10007

212-571-0437

Hand-painted, custom, and production canvas floor cloths.

Merida Natural Fiber Flooring

P.O. Box 1071

Syracuse, NY 13201

800-345-2200

Natural fiber floors and a wide choice of unusual bindings.

Paris Ceramics

979 Third Avenue

New York, NY 10022

888-845-3487

Limestone, terra cotta, antique stone, and hand-painted tiles.

Safavieh Carpet

153 Madison Avenue

New York, NY 10016

888-723-2843

Vegetable-dyed rugs.

Susan Sargent Designs, Inc.

Route 30

Pawlet, VT 05761

800-245-4767

Artist-owned company creating original designs and colorful rugs.

accessories and lighting

Altamira Lighting

79 Joyce Street

Warren, RI 02885

401-245-7676

Contemporary table and floor lamps. Many have painted shades in a broad range of motifs.

Barry of Chelsea

Vintage Lights

154 Ninth Avenue

New York, NY 10011

212-242-2666

This shop specializes in Victorian and turn-of-century glass-shaded lighting whether desk, hanging, or floor. Some of the shades are beautifully painted.

Details at Home

1031 Lincoln Road

Miami Beach, FL 33139

305-531-1325

Accessories for the home.

Field Art Studio

24242 Woodward Avenue

Pleasant Ridge, MI 48069

810-399-1320

Construction of custom frames. Restoration of vintage frames.

Lava World International

A division of Haggerty Enterprises, Inc.

5921 West Dickens Avenue

Chicago, IL 60639

800-448-6837

Originators of the fun, funky lamp from the 1950s, in which colloidal masses of color form and reform in lighted transparent material of a sharply contrasting color.

Lumetta

69 Aster Street

West Warwick, RI 02893

401-821-9955

Use of form, color, and function create an exciting collection of high-quality, contemporary scones, tochères, pendants, and suspension lighting.

Pier 1 Imports

For a store in your area call

800-44PIER1 (800-447-4371)

Great home accessories, outdoor furniture, and ideas.

Shady Lady

418 East 2nd Street

Loveland, CO 80537

970-699-1080

The fine fabric shades from this retailer are especially suited to Victorian lamp styles. They come in a variety of fabrics in 24 colors with color-matched or beaded fringe edges.

acknowledgments

2 blanket Interiors Bis 3 Farrow & Ball colors 4–5 Bed, bed linen & table Interiors Bis; wooden cylinder David Champion 6 Sally Butler's house in London; 8 chocolate dragées The Chocolate Society; 14–15 cushions The General Trading Company; 18–19 vases by John Dawson from Contemporary Ceramics, paint 'Plum Brandy' from Paint Library; 20 above soap & bowl David Champion 20 below wooden container David Champion, photograph by William Abranowicz; 22–23 Siobhan Squire & Gavin Lyndsey's loft in London designed by Will White, 326 Portobello Road, London W10 5RU 0181-964 8052; 26–27 cushions & shawl The General Trading Company; 30-31 Siobhan Squire & Gavin Lyndsey's loft in London designed by Will White 326 Portobello Road, London W10 5RU 0181-964 8052; 38 paint Farrow & Ball: walls special mix of Off White no. 3 and Dead Salmon no. 28, woodwork Off white no. 3, fabric on pillow & chair Livingstone Studio; 40 all linens The White Company; 40 below left armoire & chair Josephine Ryan; 45 blanket & candle Interiors Bis; 46–47 Roger & Fay Oates' house in Herefordshire, The Long Barn, Eastnor, Ledbury, Herefordshire HR8 1EL, 01531 632718, flooring, plates, place mats & glassware Roger Oates; 48 left cushions Livingstone Studio; 48 center jars by Gilda Westerman from Contemporary Ceramics; 48 right chair Josephine Ryan, screen Catherine Nimmo, paint Dulux; 49 a house in London designed by Charles Rutherfoord, 51 The Chase, London SW4 0NP 0171-627 0182; 50–53 Keith Varty & Alan Cleaver's apartment in London designed by Jonathan Reed/Reed Boyd 0171-565 0066; 55 chocolate The Chocolate Society; 64 left artwork from David Champion; 64 above a house in London designed by Charles Rutherfoord, 51 The Chase, London SW4 0NP 0171-627 0182; 64 below chairs Twentieth Century Design; 65 left leather cube Succession; 65 top right bamboo plate David Champion; 65 center right bamboo bowl David Champion; 65 bottom right fabrics William Yeoward, Interiors Bis, Carden Cunietti; 66 top linens, bed & table Interiors Bis; 66 center pillows & blanket Interiors Bis; 66 bottom chocolate dragées The Chocolate Society; 67 paint Dulux, ceramic dish Egg, photograph by William Abranowicz, wooden container David Champion; 68-69 a house in London designed by Charles Rutherfoord, 51 The Chase, London SW4 0NP 0171-627 0182; 68 top left chair, bowl & soaps David Champion; 68 top right bathrobe The Source; 69 vanilla soap Egg, square soap David Champion; 70 above a loft in London designed by Robert Dye Associates, chairs Twentieth Century Design, wooden containers David Wainwright, bamboo plates & bowl & ceramic bowls David Champion; 70 below chocolate truffles & cocoa powder The Chocolate Society; 78 pink quilt The Gallery of Antique Costume & Textiles, brown blanket Tobias & The Angel, pink & brown throws Valerie Wade; 78–81 Roger & Fay Oates' house in Herefordshire, The Long Barn, Eastnor, Ledbury, Herefordshire HR8 1EL, 01531 632718; 80 fabrics Roger Oates; 81 below chair Josephine Ryan; 82 vases by Gilda Westerman from Contemporary Ceramics; 83 paint Paint Library, chair fabric Livingstone Studio; 83 center right lamp Valerie Wade, artwork by Zoë Hope, table Josephine Ryan; 84 far left bowls Julie Goodwin; 84 center right antique silks Catherine Nimmo; 84 main picture boxes, cup, cigar, chest, ivory cutter Bentleys, table Nordic Style; 92–93 Roger & Fay Oates' house in Herefordshire, The Long Barn, Eastnor, Ledbury, Herefordshire HR8 1EL, 01531 632718, flooring Roger Oates; 94–95 above a house in London designed by Charles Rutherfoord, 51 The Chase, London SW4 0NP 0171-627 0182; 94 above right vase & beaker by Edmund de Waal, table Nordic Style; 94–95 below Roger & Fay Oates' house in Herefordshire, The Long Barn, Eastnor, Ledbury, Herefordshire HR8 1EL 01531 632718; 95 above Roger & Fay Oates' house in Herefordshire, The Long Barn, Eastnor, Ledbury, Herefordshire 01531 632718; 95 below left chair Katherine Pole; 95 below right bowl by Sue Paraskeva; 96-97 a loft in London designed by Robert Dye Associates; 96 below left chairs, table & ladder Catherine Nimmo, paint 'Tablecloth' Paint Library; 97 center right blankets The Cross, 97 bottom right ceramic jars Carden Cunietti; 99 paint Farrow & Ball: floor Mouse's Back floor paint no. 40, cupboards Green Smoke no. 47 and interior Red Fox no. 48, walls & woodwork String no. 8, ceiling Off White no. 3; 100 top center & right vessels by Sue Paraskeva; 101 paint Paint Library; bowls Livingstone Studio; 102 pink cups Christopher Farr; 102–103 above Roger & Fay Oates' house in Herefordshire, The Long Barn, Eastnor, Ledbury, Herefordshire HR8 1EL 01531 632718; 102–103 below paint Farrow & Ball: walls Old White No. 4, woodwork and panelling Light Gray no. 17, silk Jagtar; 103 above paint Farrow & Ball: walls Bone no. 15; 104–105 Siobhan Squire & Gavin Lyndsey's loft in London designed by Will White, 326 Portobello Road, London W10 5RU 0181-964 8052; 112 plates David Champion, pillow & throw Pierre Frey; 113 rice containers Kara Kara; 114 throw Pierre Frey, tall red rice baskets Snap Dragon, black rice containers Kara Kara; 115 bottom right red lacquer plates David Champion; 116–117 Sally Butler's house in London; 117 photograph from Michael Hoppen, galvanized bin Catherine Nimmo; 118 black cups David Champion, blanket Interiors Bis; 119 top right paint 'Plum Brandy' Paint Library, vases by John Dawson from Contemporary Ceramics; 120–121 Roger & Fay Oates' house in Herefordshire, The Long Barn, Eastnor, Ledbury, Herefordshire HR8 1EL 01531 632718.

authors' acknowledgments

Many thanks to the temporarily exiled Page Marchese Norman and her wonderful sense of color, and her assistants Sally Conran and Kitty Percy. Thanks to Tom Leighton and his assistant Simon Thorpe and Greg Walker for the exquisite photographs.

We would like to thank everyone at Ryland Peters and Small for their vision, humor, and sheer efficiency—Jacqui Small, Anne Ryland, Paul Tilby, and Caroline Davison for support and encouragement on a tough schedule; Nadine Bazar and Kate Brunt, indefatigable location experts, and Karina Garrick, the complete coordinator.

Many thanks also to the people who allowed us to photograph their homes.